# The Art of
# Perspective

*The author wishes to thank his students, who were the living laboratory for this work, and Claire Savary who appears in many of the photographs.*

Published in 2011 by New Holland Publishers (UK) Ltd
London • Cape Town • Sydney • Auckland
www.newhollandpublishers.com
Garfield House, 86–88 Edgware Road, London W2 2EA,
United Kingdom
80 McKenzie Street, Cape Town 8001, South Africa
Unit 1, 66 Gibbes Street, Chatswood, NSW 2067, Australia
218 Lake Road, Northcote, Auckland, New Zealand

First published by Fleurus, Paris, in 2009 as *L'art du dessin en perspective*
Published by agreement with Groupe Fleurus
© Groupe Fleurus – Paris, 2009
© English translation, New Holland Publishers (UK) Ltd 2010

A catalogue record for this book is available from the British Library

ISBN  978 1 84773 815 8

Senior Editor: Emma Pattison
Publisher: Clare Sayer
Design: Rémi Lelievre and Chloé Eve
Translation: Barbara Beeby
Production: Laurence Poos

Reproduction by Pica Digital PTE Ltd, Singapore
Printed and bound in Malaysia by Times Offset (M) Sdn Bhd

**List of reproduced works:**

Page 126:
Jean-Baptiste Camille Corot, *L'Étang à l'arbre couché* [Pond with a fallen tree], Reims, musée des Beaux-Arts
© RMN/Agence Bulloz

Page 127:
Pierre Roy, *L'Été de la Saint-Michel* [The Saint-Michel Summer],
Attributed title: *Nature morte* [Still Life] (c.1932)
Paris, musée national d'Art moderne – Centre Georges-Pompidou
© ADAGP, Paris, 2009
© Collection Centre Pompidou, Dist. RMN / Jean-Claude Planchet

Gerhard Richter, *Jockel*, 1967
Dresden (Germany), Gemäldegalerie Neue Meister, Staatliche Kunstsammlungen
© Gerhard Richter
© BPK. Berlin, Dist. RMN/Hans-Peter Kluth

Page 128:
Raoul Dufy, *La Jetée de Honfleur* [Honfleur Jetty], 1928
Musé d'Art moderne de la Ville de Paris
© ADAGP, Paris, 2009
© RMN – Agence Bulloz

Maurice Denis, *Les Muses* [The Muses], also sometimes known as:
*Dans le parc* [In the park], 1893
Paris, musée d'Orsay
© ADAGP, Paris, 2009
© RMN (musée d'Orsay)/Hervé Lewandowski

Page 129:
Henri Lambert, *Retour de la pirogue* [Return of the pirogue], 1904
Paris, private collection

Leonardo da Vinci, *The Virgin and Child with Saint Anne*,
Paris, Louvre Museum
© RMN/Franck Raux

Page 134:
Aldo Rossi, *Bâtiment des services sociaux du port de Naples* [Social services building in the port of Naples], 1968-1980:
Preliminary study, 1st version
Paris, musée national d'Art moderne – Centre Georges-Pompidou
© Collection Centre Pompidou, Dist. RMN/ Georges Meguerditchian

Page 136:
Robert Rauschenberg, *Collage d'épreuves originales* [Collage of original proofs], 1958
Paris, musée national d'Art moderne – Centre Georges-Pompidou
© Untitled Press, Inc./ADAGP, Paris, 2009
© Collection Centre Pompidou, Dist.RMN/ Philippe Migeat

Page 137:
Ettore Sotsass, *Supercalculateur "Elea"* [Supercomputer "Elea"], 1958
Paris, musée national d'Art moderne – Centre Georges-Pompidou
© Ettore Sottsass
© Collection Centre Pompidou, Dist.RMN/ Georges Meguerditchian

YVES LEBLANC

# The Art of
# perspective

Wallace Fountain, Paris

# CONTENTS

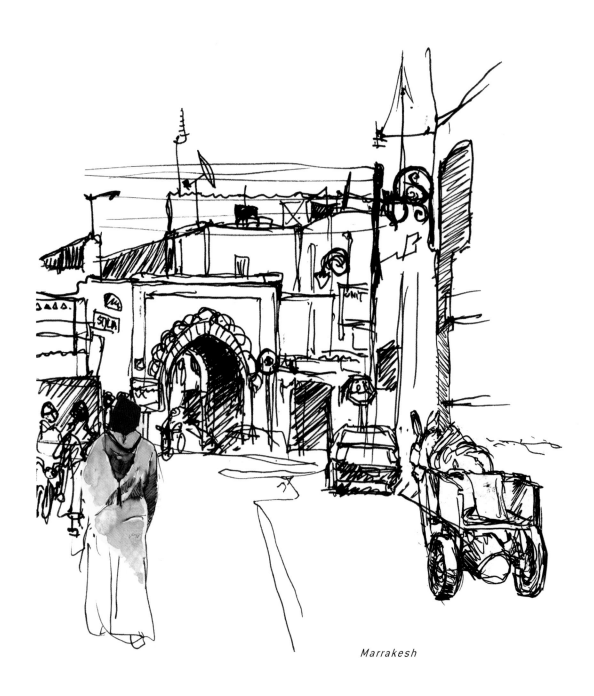

Marrakesh

# PREFACE

In the West the classical notion of perspective was developed by scholars – engineers and artists who were curious about everything – in the wake of the empirical efforts of the early Renaissance period, which in themselves were remarkable. Two preoccupations emerged early on: engineers wanted to solve the problem of the geometrical basis of lines, and painters, that of the realistic representation of space.

The trend grew stronger, and in the 17th century a classical example was offered. It was a treaty published in 1647 by Abraham Bosse, an intaglio engraver: 'M. Desargues' universal step-by-step method for creating geometrical perspective'. Artists had to resolve concrete problems but were unable do so without the help of mathematical theorems and confirmations, while mathematicians aimed not to produce an effect but to demonstrate a fact. As a result, Abraham Bosse was able to use the elegant theoretical demonstrations of the mathematician Gérard Desargues for the benefit of perspective, thus popularising the latter's works. So there is a solid classical tradition of geometrical treatment of perspective. The approach became established and in this spirit some excellent treatises were published for different purposes.

Yves Leblanc had different concerns however. As a teacher preparing students for entrance to the design course of a teacher training grande école, he was faced with the problem of a diverse class of students, some with practical experience in drawing and some complete beginners, all of whom had to be prepared for a competitive examination. The objective was clear: to teach his audience how to create the schema of a place, a space or an object in a very short space of time, to describe the methods used or to suggest a feeling or an atmosphere.

This book is clearly set out and divided into eight chapters, each of which is followed by a short summary of the main principles to remember. The clearly structured layout is skilfully developed and illustrated, but the book's originality lies in the mind of the author who has brought his vision of things to life. We are given a 'viewpoint' based on confirmed practice.

Special importance is given to the physiological factors underlying potential representations of space. The subjective-objective conflict to be resolved in each situation is clearly shown, without recourse to unnecessary technicalities. This results in an approach that is pragmatic but also free.

There is no hint of a set formula in the naturalness and simplicity that Yves Leblanc aims for. His approach is entertaining yet scholarly. From frontal perspective to three-dimensional perspective, through perspectives at an angle and horizontal perspectives, the progressive, structured journey teaches participants how to see and understand space in order to represent it with a free-flowing, light, spirited hand. Deliberately avoiding a conventional, cold and dry academic approach, it communicates what is observed, hinted at or imagined through honest drawing.

The author encourages us to think through space – to compose scenes and scenographies, work with light and shadow to create a three-dimensional, or even a thousand-dimensional, world.

Françoise Coeur
General Inspector of National Education
Applied Arts and Design

# INTRODUCTION

## Issues involved in perspective

Everyone sees the discipline of perspective differently. Some artists lacking in experience see it as a way in to a form of graphic credibility they've not yet mastered. Other more seasoned artists use it to give authority to their work. Each fosters the myth of an eternally hopeful alchemy where everything is possible.

Perspective is an attempt to 'flatten' what we see on a sheet of paper. It links graphic combinations together to explain space, just as language links words to explain thought. It involves an awareness of the space around us, calling on the artist's skills of deduction to capture a place, a direction or the way a surface behaves. Perspective is about establishing an interplay between spatial reasoning and visual disorder, organising information and providing a viewpoint: rendering a space 'graphic' and graphics 'spatial'.

Perspective is a discipline with no end, beginning with two parallel lines that lead towards the same point and becoming more sophisticated as the complexity of the situations portrayed increases. Perspective often tends to lose sight of its initial objective – reconstructing space – from one resolution to another, and becomes an end in itself. Care must therefore be taken to avoid what could become a mere feat of perspective, sanitized and conventional. The artist also has to guard against building up set formulae and automatic processes.

Perspective links graphic combinations together to explain space, just as language links words together to explain thought.

# Issues involved in drawing from observation

To counteract a pervasive and compulsive appetite for photographs, there is today an increasing desire to live in the space around us rather than store it away in a memory separate from our feelings. It's a desire to feel, capture and translate that space.

When we fill the memories of our computers in order to free up space in our own, we stop looking at the world and store it away instead, emptying our minds of its visual substance. The images no longer live in us; they become an external part of who we are.

The acts of seeing, understanding and memorizing are essential to an artist and nourish his creativity. Drawing the environment represents a form of intellectual and temporal vigilance, and the eye needs to be educated more than ever.

The most important thing in learning about perspective is to acquire a more developed and conscious perception of space. When this is achieved the view changes and with it, the artist's response. Drawing and thought take on a life of their own.

We have two feet that move forward in contact with space and carry the weight of our bodies. Similarly we have two eyes that are windows opening onto that space. Our one brain brings everything together, and it is precisely this synthesis that interests the artist. The eyes are simply the interim step between space and the drawing.

When we draw we make lines. When we look at a drawing we follow those same lines. Viewer and artist are linked – one walking in the steps of the other.

Perspective is a process that begins with space and passes through the artist and his picture to eventually be offered up to the perception of others. This path forms the basis of every drawing from observation, and the artist has to make a certain number of choices to bring it to a successful conclusion. What is the spatial situation? What is the field of vision? What is the line of sight? What will the conditions of reconstruction be?

As such, perspective obliges us to position ourselves in our relationship to space and the view of others.

Drawing is a delightful learning experience we take time to see, understand and memorize our surroundings.

Seeing is a sensory activity which is both deductive and projective.

Deductive because it has a strong power of intellectual resolution: the brain disentangles visual disorder, gives order to perception and coordinates reactions. From cells to neurones, the body takes in its environment with all the pragmatism of an organ whose sole objective is functional efficiency.

Projective because we must create an idea of the spaces we have not conquered physically. We are guided by our experience of life, and perspective is a cerebral perambulation that enables us to take possession of space intellectually.

# The parameters
## of perspective

- The observer and the field of vision
- The surface of reconstruction
- The space to be reconstructed

# THE OBSERVER AND THE FIELD OF VISION

An attempt to explain perspective enables us to understand space, perception and the relationship between an artist and his picture. For the artist, an understanding of the process itself is far more important than the application of perspective itself, as it enables him to master the relationship between space and his representation of it.

## CONES AND RODS

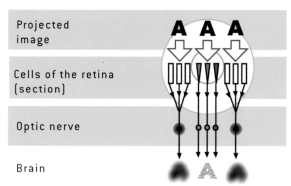

| | |
|---|---|
| Projected image | A A A |
| Cells of the retina (section) | |
| Optic nerve | |
| Brain | |

The transmission of information between the retina and the brain. The cones are in the centre. The rods are on the edges.

## An appropriate perception

The space viewed by a motionless person outside any time context is called the 'field of vision'. This general notion, which is much more limiting than it first seems, takes us to the edge of actual perception.

When we're sitting on a bus concentrating on reading the paper, for example, we still have a sense of the scene changing outside the window and we know if there are people sitting on the seats around us. It's impossible for us to give any details of the scene outside, however, or the colour of the eyes of the person sitting opposite. We **look closely** at the newspaper print, we **read** the words, we **see** the newspaper, we **sense** what is around us. The notion of what is seen and felt is very important in perspective. It determines the angle (or distance) that must be respected in relation to things in order to understand them. An artist can choose to draw whatever he wants, but where perspective is concerned we are limited to what we see.

## An unequal field of vision

The retina (the back of the eye) has two distinct parts:
• The **fovea**, which contains around 6 million cells on a surface area of 3.7mm², on which each cell (or cone) responds to colour and is independently linked to the brain.
• The **periphery**, which is mainly made up of around 120 million cells (rods) linked together in clusters, responds to light.

The independent links (cones) make the view in the centre of the field of vision more precise and the links in groups (rods) create a more approximate, and paradoxically more reactive, perception at the edges. This is why we are always aware of what's happening on the edge of our field of vision, although we have to centre our gaze on the things we 'sense' if we want to understand them more closely.

## The eye of an artist

Another characteristic of the eye is incessant movement; not blinking the eyelids, which moistens the surface of the eye, nor shifting the gaze, but a constant oscillation of the eye, 80 to 120 times per second.

This perpetual movement keeps the cells of the retina – which receive information at the point where the two areas meet – alert and allows them to change state continuously, forcing the brain to mobilize its attention at the edges. This instinctive function leads us to define space through lines, shapes and directions. The artist simply taps into this ability which is present in us all.

## Space and memory

The projection of space on the retina changes all the time, as the eye moves and as we move around. These constant changes are ordered and conveyed as the movement of parcels of information efficiently managed by 'meta cells' (complex cells), responding to simultaneous changes in other cells. From one parcel to another the information is collected, assessed according to importance and interwoven in order to make sense.

When we scan a scene with our eyes we memorize what is seen. When we observe a space or object we 'see' not only the scene in real time but also what was memorized – our perception is in a constant state of renewal as we reconstruct space. Perception takes us on an intellectual and sensory adventure that goes beyond all geometric reasoning: a real-time analysis of memory, thoughts and the body engaged with space.

### OSCILLATIONS OF THE RETINA

Projected image

Vibration of the retina

Nerve response

Dark area

Light area

Edge of the two areas

A constant movement forces our attention to the edges of surfaces.

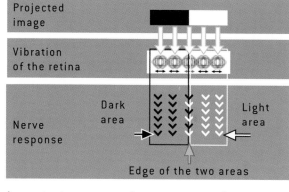

### COLLECTION OF INFORMATION

Projected image

Retina cells (surface)

Complex cells

The activation of a complex cell gives information about a vertical line (stem of the R).

## Monocular perspective
## for binocular vision

If the visual field of the left eye is placed over that of the right eye, only the central part of the scene observed is seen by both eyes – this is called the stereoscopic field. It covers a range of about 90° (45° either side of the line of sight). The observer's zone of visibility extends 180° from left to right, but only the area from -45° to +45° is seen by both eyes at the same time.

Superimposing the visual fields of the left and right eyes

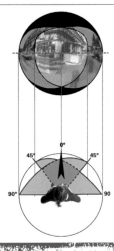

OUR EYES

The visual field of each eye
(nasal side and temple side)

## Conditions of **observation**

In the stereoscopic field the most comfortable area of observation is around 40° (we shall simplify this by increasing the angle measurement to 45°). This portion of the field corresponds roughly to a sheet of A4 paper at a distance of 42 cm (14½ in) from the face, such as a magazine on the lap, or a surface with sides of 1 m (1 yd) at a distance of 1.6 m (63 in) – a painting in an exhibition, for example.

The ratio is the same for a frame 36 mm (1½ in) wide and 24 mm (1 in) high placed 5 cm (2 in) away from the eyes. It corresponds to a 50 mm lens for a standard 35 mm camera (the 'normal' view in the schema on the following page). A wider angle gives the impression of an enlarged view.

 ## THE VISUAL FIELD

**Size of the visual field**

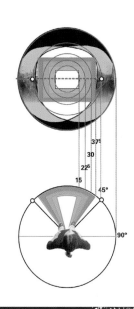

Telephoto vision
15° + 15° = 30°

Normal vision
22.5° + 22.5° = 45°

Enlarged vision
30° + 30° = 60°

Wide-angle vision
37.5° + 37.5° = 75°

If the angle of vision is even wider we move towards a combination of several 'blinks' and end up with a single representation that requires graphical compromises (anamorphosis, curvilinear perspective etc.). Photographers call this a wide-angle view (white area in the schema).

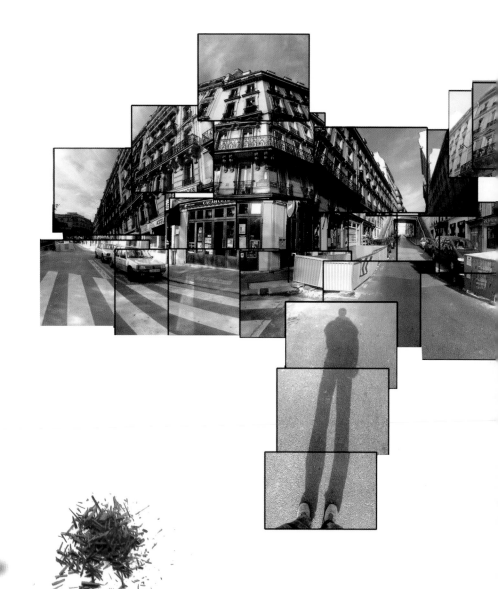

# THE SURFACE OF RECONSTRUCTION

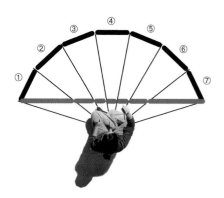
 ## Distortion **of the picture**

If we 'trace' our environment on a flat surface everything we see directly in front of us is perceived without distortion; but if we move away from the centre of vision the projection of the space is distorted.

In the schema opposite a person is looking at seven segments made up of straight lines of equal length the same distance away, observing them in exactly the same way. However, if she 'traces' the whole thing onto a transparent wall (the red line) she will draw segments of unequal lengths. Only the three central segments (3, 4 and 5) will be of roughly equivalent lengths. Segments 2 and 6 will be twice as wide as segment 4, and segments 1 and 7 will be six times wider! From his viewpoint an artist is not conscious of the distortion of his picture because what he is representing is the exact projection of what he sees. A person looking at the drawing, on the other hand, will not necessarily be standing where the artist was and his brain, which cannot ignore the fact that it's in front of a flat surface and not in a real space, will perceive the distortions of projection as drawing errors.

Therefore only the central point of a drawing is perceived without distortion. As soon as you distance yourself from that point a slight distortion has to be accepted. The greater distance, the greater the distortion.

The further the representation moves from the centre of the drawing, the greater the distortion.

## Nature of the surface

The ideal drawing surface would be a **spherical surface** around the artist. The measurement of all the angles in his view would be respected, whatever their direction. Unfortunately, such a surface cannot be flattened.

We therefore have to be satisfied with drawing on a **flat surface** (the picture plane), which many artists think of symbolically as the end of the cone of vision (hence the term 'conical perspective').

There is no point in calculating anything in terms of conical perspective beyond a visual radius of about 80° (40° either side of the centre of the picture) because the distortion would be such that the picture would no longer be a true reflection of the actual scene.

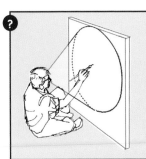

**?** **Cone of vision:** the narrow end corresponds to the observer and the wide end to the flat picture surface. The edges of the cone define the artist's visual field.

 THE PROJECTION SURFACE

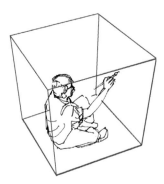

The ideal drawing surface would be a sphere surrounding the artist.

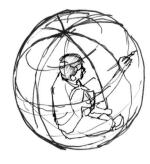

The projection of space on a flat surface leads to distortion.

A passenger in a car is aware of the driver, the dashboard and the side of the road all at the same time. However, several drawings are required to represent the whole of his visual field.

# THE SPACE TO BE RECONSTRUCTED

 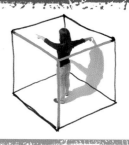

## ■ The right angle

The world by its nature, where gravity and the ground are opposed (height versus horizontal plane), is orthonormalized on the human scale. Plants originate on a horizontal earth and grow vertically. The vocabulary we use to describe three-dimensional notions is also orthonormalized: **'in front of'**, **'behind'**, **'on the left'**, **'on the right'**, **'above'**, **'below'**. It reflects a world constructed and measured by man. The notions of equilibrium, architecture and design invariably work with right angles, although the eye is free to turn in any direction it chooses. This concrete world is naturally divided into three dimensions: depth, width and height.

Plants and trees originate on a horizontal earth and grow vertically.

## ■ The centre of vision (principal point of vision)

Imagine that an observer – an artist – places a sheet of transparent paper between himself and the space he's looking at and traces what he sees. The centre of the space he's looking at will be in line with the centre of the paper. This point (the centre of the paper) represents the direction he's looking in. It corresponds to the centre of his vision, and therefore, necessarily, to the centre of the picture. In writings about perspective this is called the centre (C), the principal point of vision (PV) or point O.

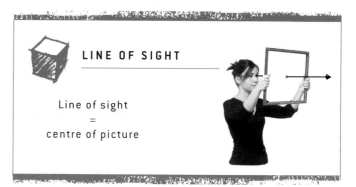

**LINE OF SIGHT**

Line of sight
=
centre of picture

 **Orthonormalized:** established on an orthogonal basis, where each axis uses an identical norm.

18

## CENTRED HORIZON

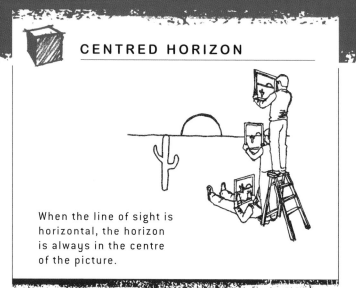

When the line of sight is horizontal, the horizon is always in the centre of the picture.

## OFF-CENTRE HORIZON

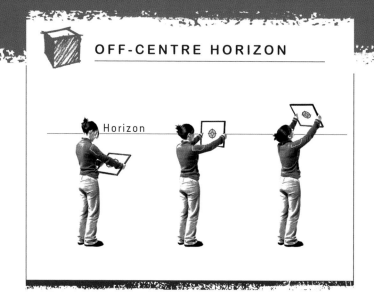

Horizon

## Distance and the horizon

When the line of sight is perfectly horizontal the horizon line is exactly in the middle of the picture. The horizon is the most distant point visible in a flat landscape. When directed towards the horizon, the eye looks neither down towards the ground nor up towards the sky: it is unwaveringly horizontal! If it ceases to be horizontal, the horizon line may disappear from the drawing area.

Distance does not fundamentally change perspective, it simply affects the enlargement ratio, rather like a photographic slide projected onto a wall: the further away the projector, the larger the image, but it's always the same image. Only when the artist's viewpoint moves does the perspective change.

 **Horizon:** a straight line that symbolizes the horizontal plane passing through the artist's line of sight.

**Distance:** the distance between the artist and the picture plane.

The distance between the artist and the picture affects the enlargement ratio of the picture.

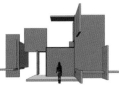

## THREE SITUATIONS

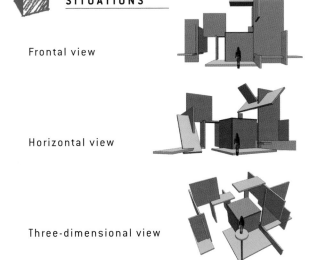

Frontal view

Horizontal view

Three-dimensional view

# The artist's viewpoint

When the artist reconstructs the three dimensions of space on the picture plane he is faced with different levels of complexity depending on the orientation of his line of sight. We shall examine the situations he is likely to meet by placing him in front of a cube whose sides represent the three dimensions of space (height, width and depth). In a way the cube will be a synthesis of the space around the artist. We shall go from the simplest case (frontal perspective) to the most complex (three-dimensional perspective). Each perspective will give the opportunity to deal with a number of questions relating to the viewpoint under consideration.

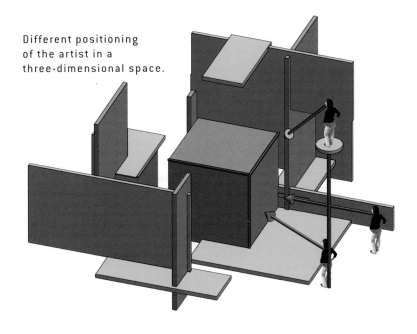

Different positioning of the artist in a three-dimensional space.

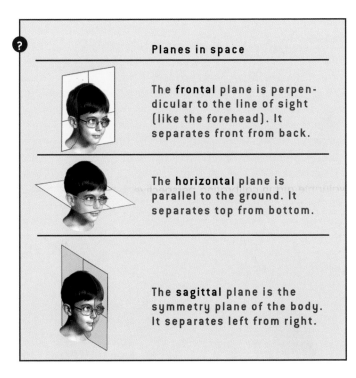

**?**

### Planes in space

The **frontal** plane is perpendicular to the line of sight (like the forehead). It separates front from back.

The **horizontal** plane is parallel to the ground. It separates top from bottom.

The **sagittal** plane is the symmetry plane of the body. It separates left from right.

## A progressive exercise

In a three-dimensional orthonormalized context, three important types of situation have been identified in relation to perspective:

• **Frontal perspectives.** Two of the three spatial dimensions (being height and width) are perpendicular to the gaze; only depth is subject to the effect of perspective. This is how we perceive a corridor, for example, when we look at the far end of it.

• **Horizontal perspectives.** These are based on a central horizon line on which most construction lines are coordinated. Only one of the three dimensions of space is perpendicular to the gaze – height. So the effect of perspective applies to the other two dimensions. This is the case for most viewpoints when the gaze is horizontal. In such circumstances height alone is perpendicular to the gaze and not subject to the effect of perspective.

• **Three-dimensional perspectives.** The eye moves in any direction in a space whose three dimensions (height, width and depth) undergo a shrinking effect in perspective. This assumes that the gaze is no longer horizontal, which is why we talk of 'downward' and 'low-angle' views.

In the orthonormalized context the difficulty in establishing a measurement depends on the extent to which the perspective includes vanishing lines. Finding a size is difficult if there is no frontal landmark whose measurement provides a valuable aid in calibrating perspective.

**Frontal perspective**

One dimension in perspective

Two measurable dimensions

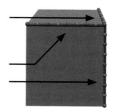

**Horizontal perspective**

Two dimensions in perspective

One measurable dimension

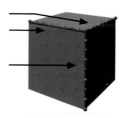

**Three-dimensional perspective**

Three dimensions in perspective

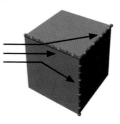

# Principles to remember

Before we begin to create a picture where there's a relationship between what we see and what we intend to recreate, we must ask ourselves a number of questions. What's the range of our field of vision? How much of it do we want to recreate? What's our line of sight?

*An afternoon above the town*

## The field of vision

This is between 30° and 75° depending on the area of interest.

Telephoto vision
15° + 15° = 30°

Normal vision
22.5° + 22.5° = 45°

Enlarged vision
30° + 30° = 60°

Wide-angle vision
37.5° + 37.5° = 75°

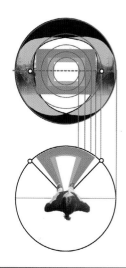

## Distortions

The more we move away from the centre of the picture, the more we must accept distortions.

## The line of sight

The centre of the picture corresponds to the line of sight.

# Frontal
## perspective

In a frontal perspective the artist looks at the space, taking into account the line of the faces that are visible. The viewpoint is horizontal. Two of the three spatial dimensions are perpendicular to the gaze (height and width): this is the frontal plane. This plane is not subject to the effect of perspective and only distance, or depth, is subject to foreshortening.

Conditions of observation

A single vanishing point

Dimensions and scales

# CONDITIONS OF OBSERVATION

● The observer looks horizontally towards the centre of a cube, which is a synthesis of the space observed. The cube is oriented according to the same principal dimensions (height, width and depth).

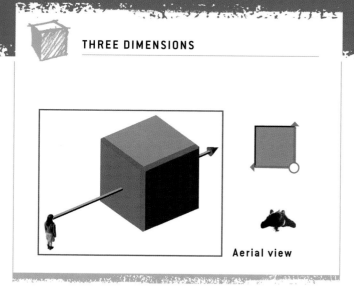

### THREE DIMENSIONS

Aerial view

● The three dimensions of space (height, width and depth) are represented by three red edges.

● A flat transparent surface is inserted, perpendicular to the observer's gaze, and on it he must 'trace' what he sees. Analysis of what happens to the three dimensions of space will take place on this surface.

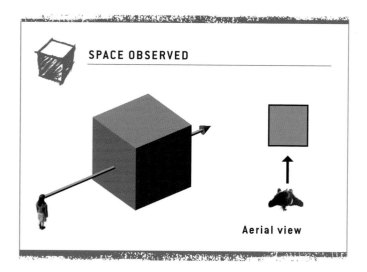

### SPACE OBSERVED

Aerial view

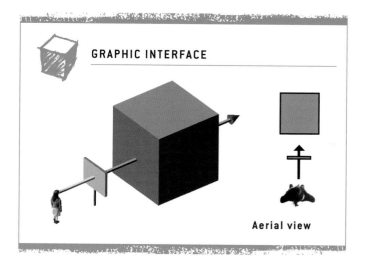

### GRAPHIC INTERFACE

Aerial view

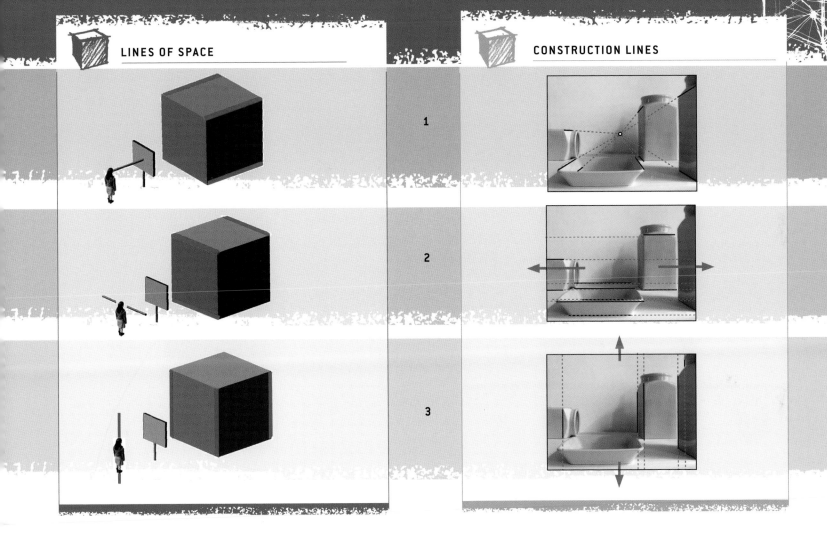

- 1. **Depth** leads towards the centre of the image.

- 2. **Width** will never meet the drawing area.

- 3. **Height** will also never meet the drawing area.

- 1. All the depth lines, which are parallel to the artist's line of sight, lead **towards** the precise point in **the centre of the image** where his gaze is directed.

- 2. All the lines that cross the artist's field of vision **from left to right** are parallel to the image and are seen with no effect of perspective.

- 3. All the vertical lines are also parallel to the image and cross it **from top to bottom**, with no effect of perspective.

# A SINGLE
# VANISHING POINT

● For the artist, straight lines parallel to each other seem to recede towards one specific point, hence the term 'vanishing point'. In the examples opposite this point represents the line of sight.

By analysing the three main dimensions of space at the precise point of observation, we see the directions they take for the artist.

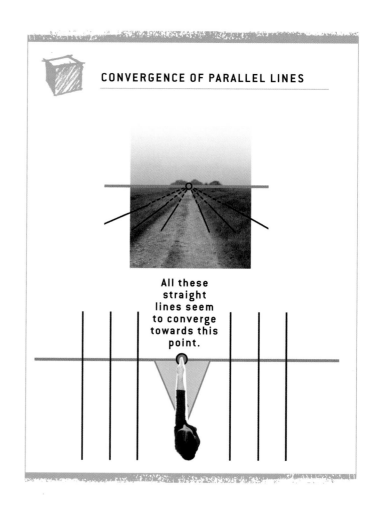

**CONVERGENCE OF PARALLEL LINES**

All these straight lines seem to converge towards this point.

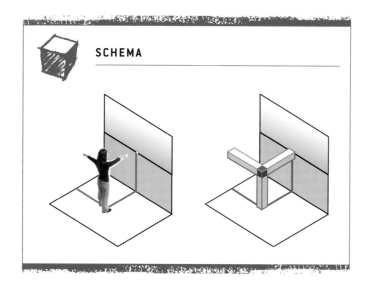

**SCHEMA**

● In a frontal perspective the depth leads towards the centre of the picture (the line of sight), while the width and height, which are parallel to the edges of the picture, appear to cross it from one side to another without ever entering it in depth.

 SCHEMAS

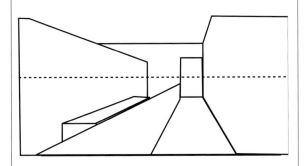

 **Vanishing point:** the point towards which all straight lines leading in a given direction seem to recede. For the artist it's a point of convergence, but for the person looking at the picture it's a direction.

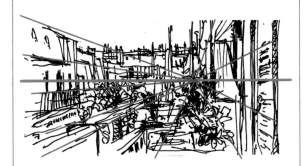

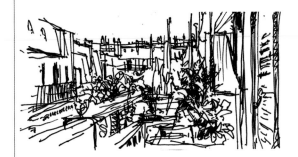

*View from the balcony*

*London, number 3 bus*

*Marrakesh, Bâb Taghzout*

# DIMENSIONS AND SCALES

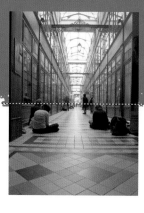

horizon (1 m/ 40 in)

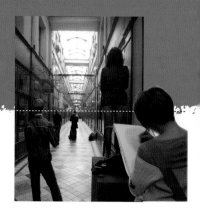

horizon (1.6 m/ 63 in)

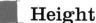

## Height

In a frontal perspective the artist's line of sight is horizontal. It extends towards infinity and ends at horizon level. This is why the artist's horizon indicates his eye level. Knowing that eye level acts as a reference for the rest of the picture and the horizon, this then becomes the standard measure for the perspective.

● When an artist is standing up his line of sight is about 1.6 m (63 in) above ground level, at eye level with other people. So for him, the eyes of everyone his height will be on the same plane. If he sits down his line of sight drops to about 1 m (40 in) above ground level, to the waist level of people standing up. So for him, waists will all be at the same level.

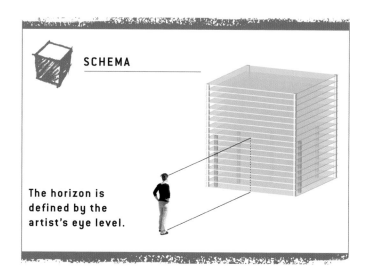

SCHEMA

**The horizon is defined by the artist's eye level.**

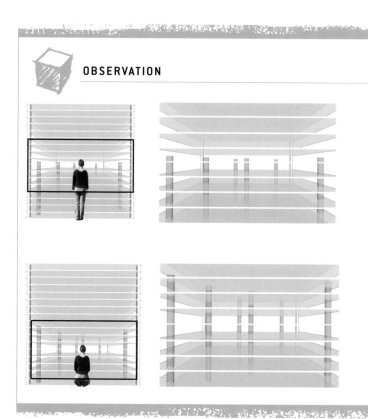

OBSERVATION

When the height of the artist's line of sight (horizon line) is known, it is possible to calculate any height at any point from the ground by a simple rule of three.

Remember that the horizon remains in the centre of the picture because the line of sight is horizontal. Raising the horizon line opens up the top part of the image, while dropping it makes the lower part of the image more visible (the ground near the artist). However, there is nothing to prevent the artist from reframing the picture later, depending on the effect he's aiming for and the area of interest of the subject.

## SCHEMA

1.6 m
(63 in)

horizon

1 m
(40 in)

**A point on the ground**

**Finding a height of 2.8 m (3 yds) from several points on the ground**

2.6 m
(103 in)

1.6 m
(63 in)

0 m
(0 in)

## RECONSTRUCTION

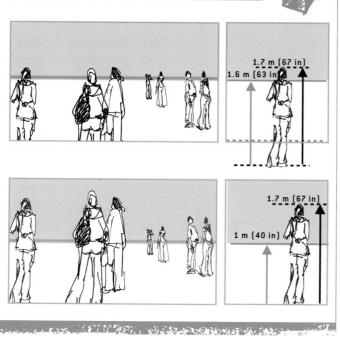

1.7 m (67 in)
1.6 m (63 in)

1.7 m (67 in)
1 m (40 in)

If several different heights are to be transferred to the picture the task can be systematized by constructing a series of references according to the heights to be placed. This is referred to as a 'scale of heights'. To do this you need to imagine a wall leading to a point on the horizon, on which height references are marked. The wall will act as a reference for projecting heights in relation to distances.

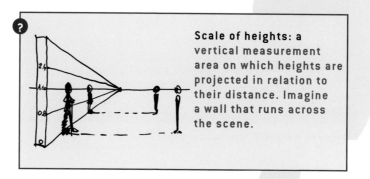

**Scale of heights: a** vertical measurement area on which heights are projected in relation to their distance. Imagine a wall that runs across the scene.

# Width

Width is given by rotating height through 90° in the frontal plane.

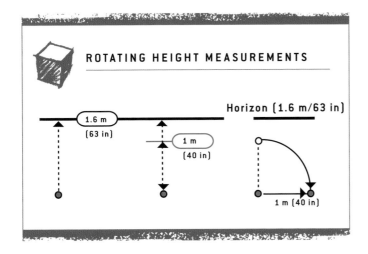

**ROTATING HEIGHT MEASUREMENTS**

Horizon (1.6 m/63 in)

1.6 m (63 in)

1 m (40 in)

1 m (40 in)

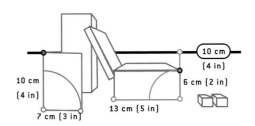

10 cm (4 in)

10 cm (4 in)

6 cm (2 in)

7 cm (3 in)

13 cm (5 in)

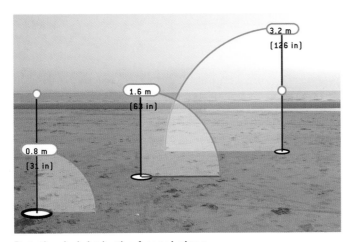

3.2 m [126 in]

1.6 m [63 in]

0.8 m [31 in]

**Rotating height in the frontal plane**

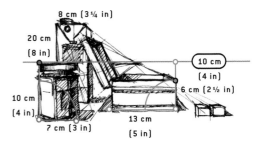

8 cm (3 ¼ in)

20 cm (8 in)

10 cm (4 in)

10 cm (4 in)

6 cm (2 ½ in)

7 cm (3 in)

13 cm (5 in)

**Obtaining height and width measurements in relation to a horizon line 10 cm (4 in) away**

## ■ Depth

A single vanishing point does not allow depth to be determined with certainty. With a reference measurement – the artist's eye level (horizon line) or the size of an element in a frontal plane – only height and width can be calculated. So depth is left to the assessment of the artist. Once this has been determined or specified, however, it is possible to consider relative depths based on the geometric division of space.

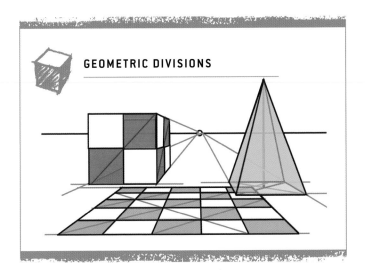

**GEOMETRIC DIVISIONS**

**SCHEMAS**

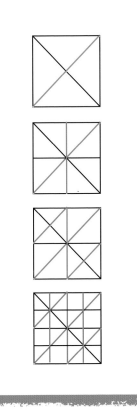

**?** **Geometric division of space:** geometric division is based on a deductive approach to the perspective space already in place. The artist uses his knowledge of geometry to follow principles of geometric logic based on intersection, construction and division.

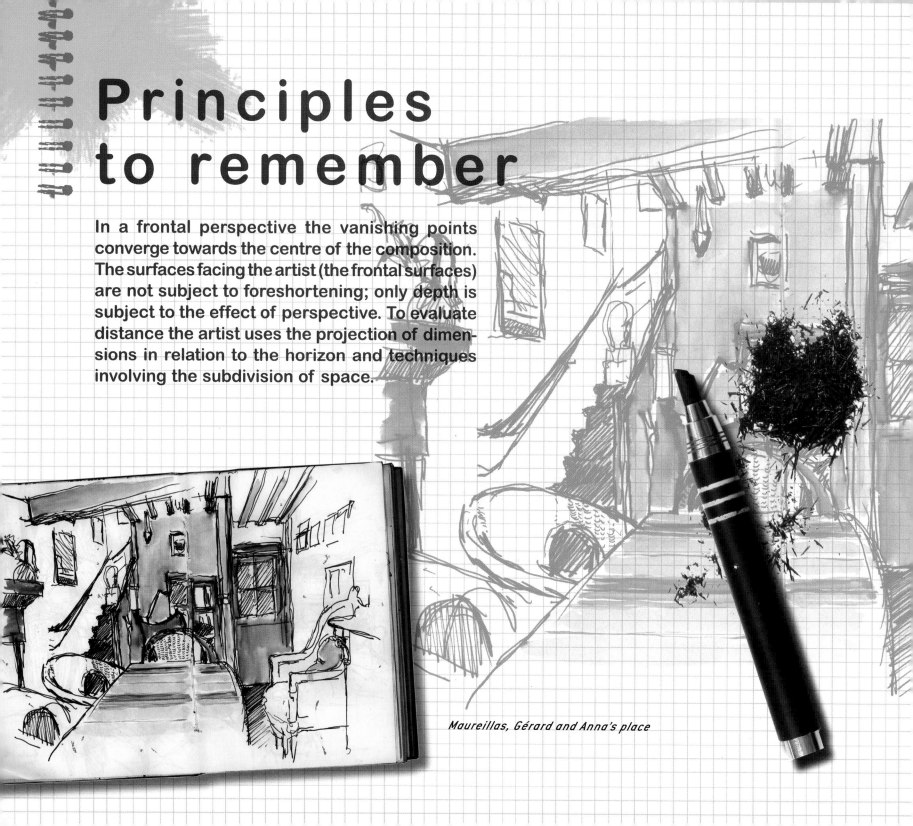

# Principles to remember

In a frontal perspective the vanishing points converge towards the centre of the composition. The surfaces facing the artist (the frontal surfaces) are not subject to foreshortening; only depth is subject to the effect of perspective. To evaluate distance the artist uses the projection of dimensions in relation to the horizon and techniques involving the subdivision of space.

*Maureillas, Gérard and Anna's place*

## Measuring height

Height is measured from the horizon line, which represents the artist's eye level.

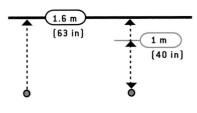

1.6 m
(63 in)

1 m
(40 in)

## Measuring width

Width is measured by rotating height through 90° in the frontal plane from a reference point on the ground.

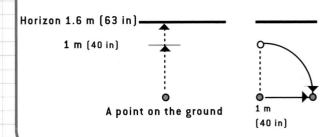

Horizon 1.6 m (63 in)

1 m (40 in)

A point on the ground

1 m
(40 in)

## Scale of heights

A scale of heights makes it possible to project any point of the space at a determined height.

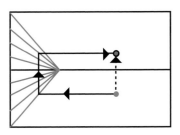

## Subdividing a surface

Relative depth can be obtained by dividing up a known measurement.

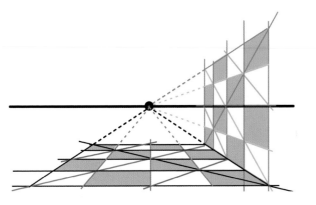

The artist's eye constantly translates angles into spatial information, like a geodesic device. For the eye in its socket, and consequently for the artist in his environment, each point in space has a precise corresponding orientation. In this chapter we shall look exclusively at the orientations at 45° each side of the artist's gaze. This, together with frontal perspective, will enable us to calibrate the perspective and fix points in space using geometric deduction.

# The 45 points

# 45L AND 45R

● We have already seen that all straight lines parallel to the artist's gaze appear to finish in the centre of the picture. In the same way, the lines that lead off at 45° either side of his gaze will appear to end on the left and the right. These new construction lines will act as additional reference points to aid construction of the picture.

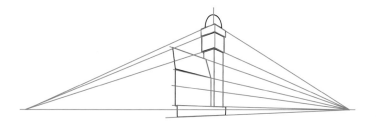

● Each construction line has a corresponding vanishing point on the horizon line.

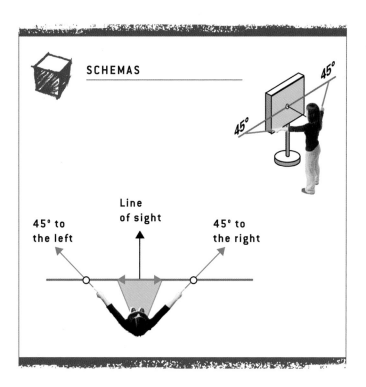

**SCHEMAS**

45°

45°

Line of sight

45° to the left

45° to the right

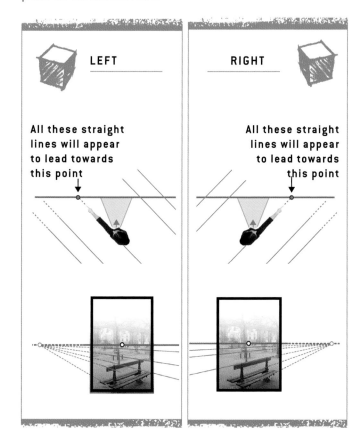

**LEFT**

All these straight lines will appear to lead towards this point

**RIGHT**

All these straight lines will appear to lead towards this point

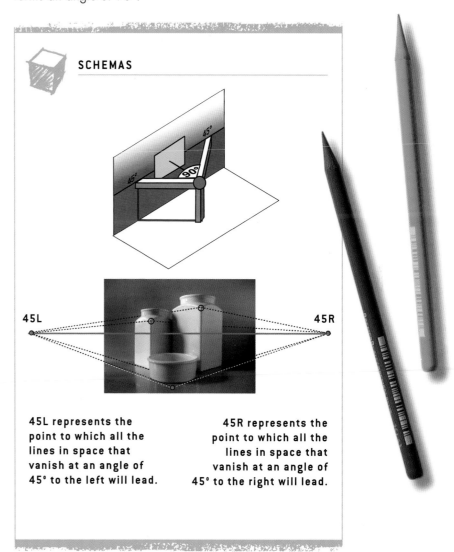

## TWO CONSTRUCTION LINES AT RIGHT ANGLES

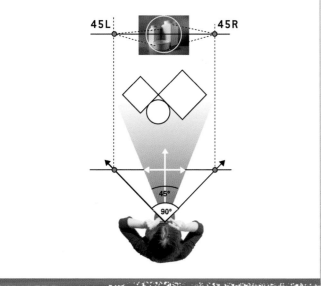

● The intersection of the lines from the two marked points forms an angle of 90°.

### SCHEMAS

● For the artist, a line leading to 45R and another leading to 45L intersect in reality at right angles. So points 45L and 45R make it possible to establish a measurement of angle in perspective.

In many books on perspective these points are called the 'distance' points and are written as 'D'. Moreover, in the case of a 45° angle the distance between the artist and the picture plane (or in geometry, the distance between the observer and the projection plane) is the same as the distance between one of these points and the centre of the picture.

However this is of secondary importance. Only the construction line that this point represents is of any importance to the artist. So we have chosen to call it 45L when it's on the left of the picture and 45R when it's on the right.

**45L** represents the point to which all the lines in space that vanish at an angle of 45° to the left will lead.

**45R** represents the point to which all the lines in space that vanish at an angle of 45° to the right will lead.

# DISTANCING OF THE ARTIST

● Objects that are further away from us take up less space in our field of vision. Moreover their proportions seem to change; prominent edges seem less sharp and contours are less marked. In accordance with the laws of optical geometry, distant objects appear smaller. Drawing something close to or at a distance requires the artist to focus his attention on part of his field of vision that varies in length, but where left and right appear fixed.

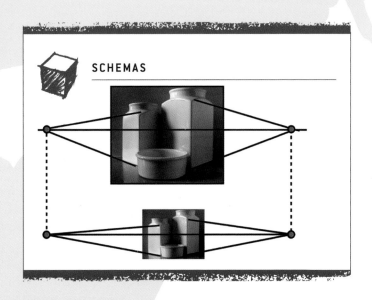

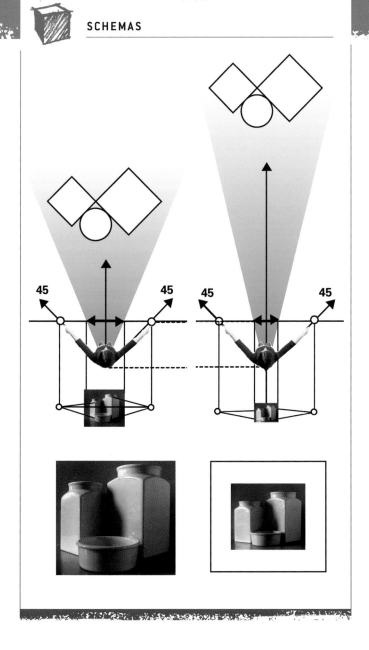

The '45' points act in the same way, as reference points in the visual field. So an object will feel close or distant depending on how much space it occupies in relation to these reference points.

We might expect a drawing scale to be directly related to how far away the subject of the drawing is positioned. However in practise an artist represents a scene he's chosen according to the format of the picture plane or the size of his sketch book, not according to how far away he is.

The question we must ask is, 'How can we represent the fact that an object is near or far away, since the dimension of the picture is not a determining factor?' or, 'What's the difference between an object seen close to and one seen at a distance?'.

**Near view**

**Distant view**

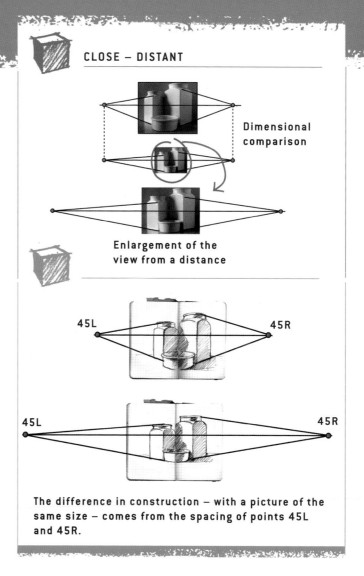

### CLOSE – DISTANT

**Dimensional comparison**

**Enlargement of the view from a distance**

45L      45R

45L      45R

**The difference in construction – with a picture of the same size – comes from the spacing of points 45L and 45R.**

● When the size is the same, the gap between the vanishing points changes. The closer the artist is to the scene, the closer the vanishing points are to each other: the perspective then appears emphasized and edges are sharper. Conversely, when the artist moves further away, edges appear less prominent and the perspective more 'squashed'.

41

# ANGLE OF VISION

When drawing in perspective the artist must position points 45L and 45R judiciously, and he must do so from the start. The distance from one '45' point to the other is closely linked to the feeling of proximity or distance depending on the size of the picture, and vice versa (see pp. 40-41).

## Defining the size of the picture according to points 45L and 45R

We have seen that all straight lines leading at 45° each side of the artist's line of sight seem to finish at points 45L and 45R. It is therefore possible to reverse the journey and locate the artist's gaze from these points. Once the observation point has been located, a drawing area can be defined by marking out an appropriate angle of vision (30°, 45°, 60° or 75°).

This involves a kind of to-and-fro movement between the artist's eye and the picture. The artist has to work on a flat surface and so he uses the rabatment technique for this.

? **Rabatment:** a process that consists of rotating a measurement taken in the depth of the visual field on the picture plane.

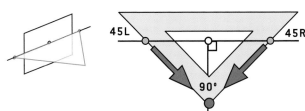

45L    45R    90°

The observation point is deduced using the two 45 points.

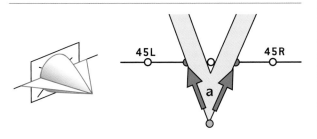

45L    45R    a

The angle of vision is drawn from the observation point according to the angle of vision considered (30°, 45°, 60° etc.).

45L    45R

The drawing area is established between the two reference points (blue dots) that mark the left and right edges of the angle of vision.

# Positioning points 45L and 45R according to a drawing area

The artist defines the position of 45L and 45R according to the position of his drawing in the picture plane and the size he wants it to be. In this situation he will work in the opposite way to that described on the previous page. As the drawing area is defined from an observation point in accordance with a very precise angle of vision (30°, 45° or 60°), it is possible to reverse the process and locate the observation point from the drawing area if the choice of angle is known. Once this point has been located, all that's necessary is to project lines at 45° each side of the line of sight to arrive at points 45L and 45R using the rabatment technique.

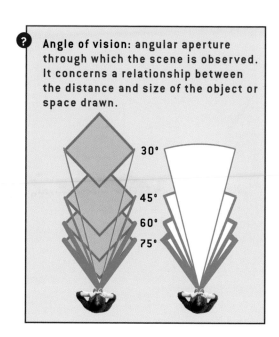

**?** **Angle of vision:** angular aperture through which the scene is observed. It concerns a relationship between the distance and size of the object or space drawn.

30°
45°
60°
75°

The drawing area is defined by the size of the paper or space allowed for the perspective drawing (here, a double page in a sketch book).

The observation point is deduced by sliding a set square along the edges of the proposed drawing in accordance with a chosen angle of vision (30°, 45° or 60°).

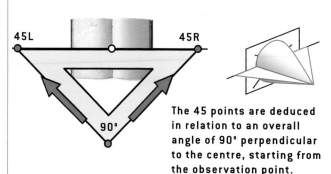

45L    45R

90°

The 45 points are deduced in relation to an overall angle of 90° perpendicular to the centre, starting from the observation point.

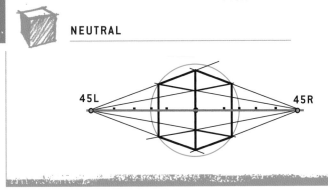

# Choosing an angle of vision

The artist chooses an angle of vision according to the visible area he wishes to replicate (telephoto, neutral, enlarged or wide-angle view). This choice is independent of the orientation of his line of sight, which is fixed and represented by stable reference points (45L and 45R in the examples opposite).

The size of the drawing (on the 45L-45R scale) varies according to the artist's field of vision. The only consequence of changing the distance between 45L and 45R would be a general change in the scale of the drawing. The main angles that are easy to find using two set squares are 30°, 60° and 45°.

**NEUTRAL**

● 45°, the neutral view
This is the most natural view for the artist. It allows a faithful rendering of what is seen in optimum conditions of observation.

● 30°, the telephoto view
This view is often used in architecture. Close to the elevation, it gives a 'squashed' perspective, but it has the advantage of reconstructing depth more consistently. There is less difference between foreground and background foreshortening.

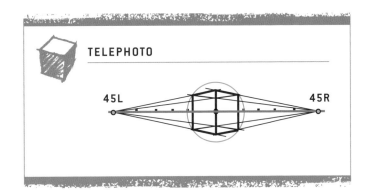

**TELEPHOTO**

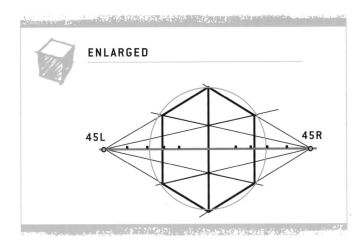

**ENLARGED**

● 60°, the enlarged view
The enlarged view emphasizes the effect of perspective and makes construction easier because of greater proximity to the vanishing points.

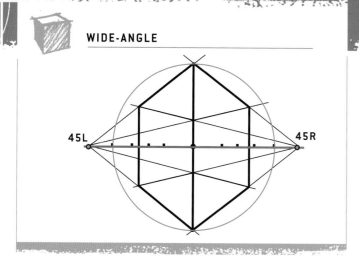

45L          45R

● 75°, the wide-angle view
This view appears distorted but it can nevertheless be used with a drawing style where suggestion takes precedence over description as one moves away from the centre of vision.

## Credibility and tolerance of distortion

No one view is more correct than any other. The choice of angle depends on the dimensions of what's seen and the distance from which it's viewed. A house can be viewed from a distance equal to its largest dimension, whereas one has to move away by at least five or six times the largest dimension of a box of matches to see it in normal conditions of observation.

Having said that there's no limit to the observation distance of a space as it surrounds us. We are talking in very general terms, however, since an artist is free to look at a box of matches closely, a house from a distance or an indoor space without its walls.

So it's a question of the ratio between distance and size or, in other words, a reasonable angle of vision which the artist will define according to two subjective criteria:
- the credibility of the distance with regard to the type of spatial situation he wishes to portray;
- his tolerance of distortion and anamorphosis which are guaranteed to increase in relation to the size of his cone of vision (see pp. 16-17).

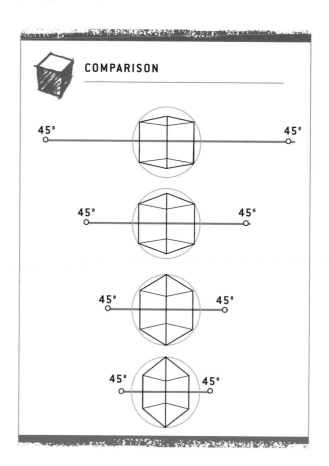

COMPARISON

45°          45°

45°          45°

45°          45°

45°          45°

# INTERSECTING INFORMATIONS

## Drawing a square

This involves deducing distances by geometrical intersection, when two distinct orientations are known:
- The artist's line of sight (the centre of the picture).
- One of the '45' points (45L or 45R).

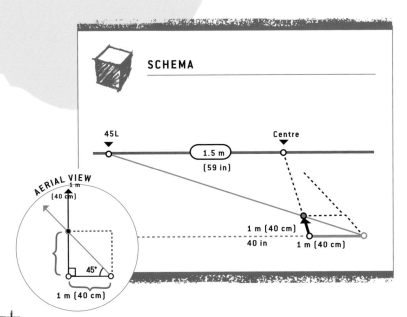

### SCHEMA

45L    Centre

1.5 m
(59 in)

AERIAL VIEW
1 m
(40 cm)

1 m (40 cm)
40 in
1 m (40 cm)

1 m (40 cm)

45°

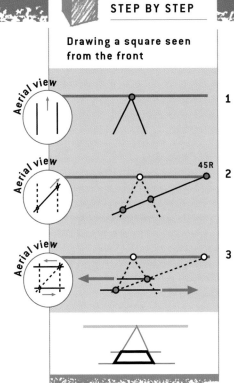

**STEP BY STEP**

Drawing a square seen from the front

Aerial view

1

Aerial view          45R

2

Aerial view

3

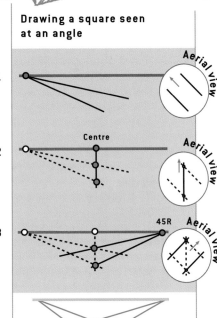

**STEP BY STEP**

Drawing a square seen at an angle

Aerial view

1

Centre          Aerial view

2

45R
Aerial view

3

## Step by step

### 1. The first two sides
Two parallel lines are drawn somewhere in a space and therefore converge towards the same point on the horizon line in the picture.

### 2. The diagonal
This is drawn at any distance at an angle of 45° to the first two sides and so leads towards 45R (from the front) or towards the centre (at an angle).

### 3. The last two sides
Drawn from the intersection obtained perpendicular to the first two sides, they are parallel to the horizon line (from the front) or they converge towards the other 45 point (at an angle).

# Taking a measurement
## on the diagonal

To take a measurement on the diagonal two construction lines must be used: the centre and one of the two 45 points (45R or 45L).

In the example below, two squares have been drawn in the frontal plane (yellow). Measurement of the diagonals is obtained when the height of the horizon is known. The principle involves making the squares 'fall' to the ground using the construction lines of perspective. One of these lines corresponds to the sight line and so leads to the central vanishing point, and the other corresponds to an orientation of 45° to the right of the sight line, leading to 45R. Thus the diagonal on the ground is found.

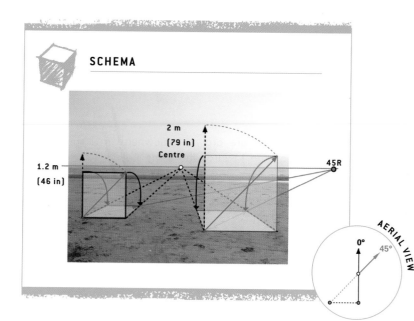

SCHEMA

EXAMPLE

Here, a distance of 2 m (79 in) is drawn on the diagonal.

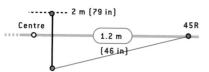

**1. Draw an orientation at 45° to the line of site (the centre).**

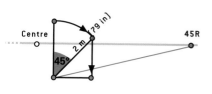

**2. Deduce a height of 2 m (79 in) in relation to the horizon.**

**3. In the frontal plane find a side of the square (blue dots) with a diagonal of 2 m (79 in).**

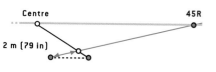

**4. Reconstruct the 2 m (79 in) diagonal in the perspective space using the side of the square.**

# SYSTEMATIC CONSTRUCTIONS

Many instruments have been used by navigators, geographers and astronomers to measure angles, deduce distances and control directions.

● For the artist, the measurement of an angle is given by positioning point 45R (or 45L) and his line of sight (the centre of the picture).

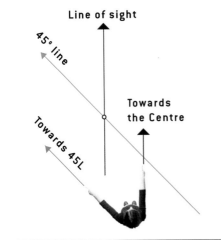

Line of sight

45° line

Towards the Centre

Towards 45L

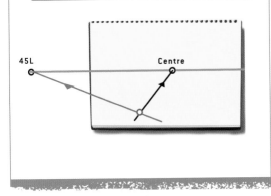

45L          Centre

**Left/right Indicator (aeronautics)**

**Sextant**

**Theodolite**

**Clinometer**

# Perspective as a system

Locating points from an aerial view according to two construction lines makes it possible to place them in perspective space systematically. The two construction lines will act as horizontal and vertical co-ordinates.

Although we are straying somewhat from the principles of this book – whose objective is to solve the visual aspect of space when creating a picture – we shall mention two other frequently used methods, to make a link with other perspective techniques. These are **creating a grid** (perspectives in a screened space) and the **rabatment of a plane** (construction by intersection at 45°). These principles provide an exercise in mental gymnastics because they require repeated movement between the perspective space and the picture plane, but they can be very useful in complex situations. They must be used discerningly however, as they risk leading the artist into codifications that are not necessarily compatible with our view.

With a systematic approach it is mathematically possible to construct perspective outside the field of vision. However the artist can get carried away by the intricacies of a perspective solution established point by point and no longer knows when to stop, continuing his construction logically beyond what is reasonably visible. The irony is that the artist has justifiably used perspective to gain visual credibility.

Moreover, the disadvantage of a systematic process is that it can be a substitute for reasoning, which is of prime importance in understanding space. Just one false step in the process and a construction that has not been thought through can easily turn into an incoherent space.

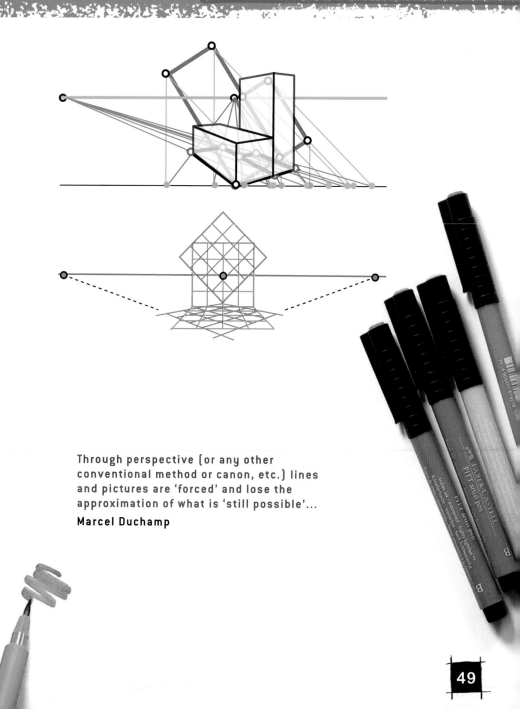

Through perspective (or any other conventional method or canon, etc.) lines and pictures are 'forced' and lose the approximation of what is 'still possible'...
**Marcel Duchamp**

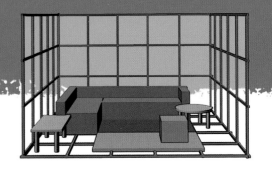

# CREATING A GRID

Constructing a grid makes it possible to reconstruct a plane by screening a space, like 'squaring up'. Although the following operations are applied to a frontal perspective, they are possible because the diagonal of the square (45L or 45R) is known, which means that the screen can be drawn with the certainty that the depth is in accordance with the other dimensions.

 ## Frontal grid

Here we are giving volume to some living room furniture using the plane opposite:

**1. Frontal screen**
The frontal wall (3 m / 115 in by 5 m / 200 in) is divided into regular squares.
**2. Drawing the vanishing lines**
The horizontal vanishing lines are drawn starting from the sight point (blue lines).
**3. Diagonal intersecting**
The diagonal of the screen to be drawn is marked according to point 45L (or 45R).
**4. Screening on the ground**
A screen based on square units is drawn on the ground.
**5. Building the side walls**
The walls are built on each side.

**STEP BY STEP**

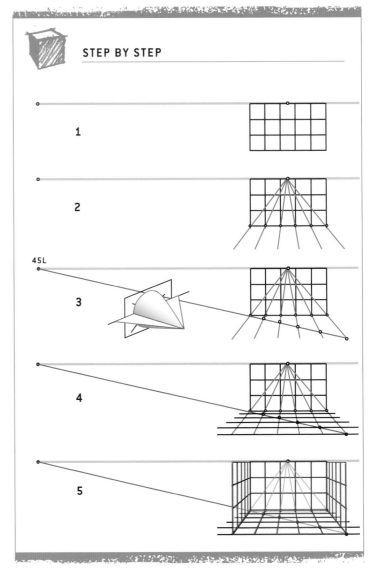

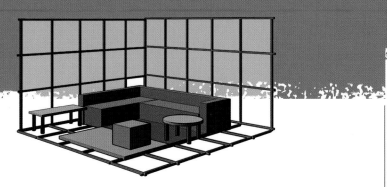

## Grid at an angle

Here we are giving volume to some living room furniture using a plane inclined at 45°:

### 1. Screening of the plane
The plane (a square with sides of 5 m / 200 in) is squared up. One of its sides is projected on the diagonal (towards 45R) using frontal rabatment.

### 2. Tapering to the left
The screen running perpendicular to the side already marked is drawn towards 45L.

### 3. Diagonal intersecting
The diagonal of the screen is drawn from the central perspective point.

### 4. Tapering to the right
The lines leading towards 45R are drawn using diagonal intersection.

### 5. Building the side walls
The vertical screens are drawn from the points of contact on the ground and the walls.

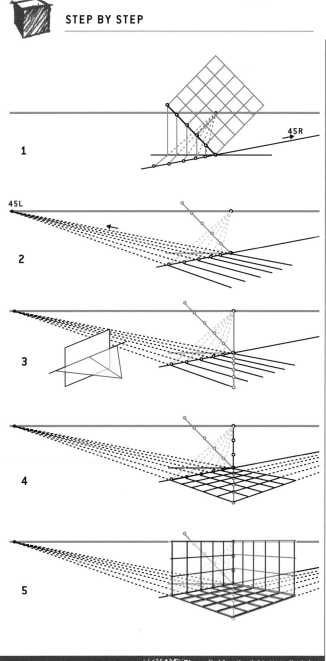

# RABATMENT

## The principle of rabatment

Rabatment is a systematic process that makes it possible to position any point in perspective through the intersection of two construction lines at 45° to each other. The principle consists of introducing a plane vertically (therefore with no effect of perspective), locating the position of the principal points (the intersection of two construction lines) and rotating the scene down to the ground line. This operation is referred to as rabatment (see definition, p.42). It is worth noting that although the technique of rabatment of a plane is systematic and should be used discerningly, it can prove very useful for carrying out complex operations such as creating perspective from a plane.

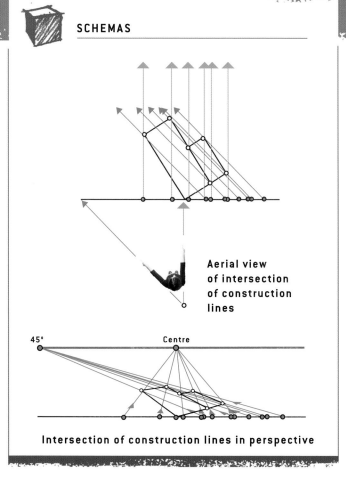

Aerial view of intersection of construction lines

45°    Centre

**Intersection of construction lines in perspective**

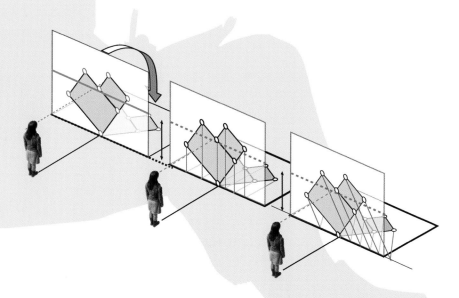

Before tackling construction using rabatment it is necessary to establish the ground plane of the volume to be constructed. The scale of the plane is given by locating the height of the horizon at the line of rotation. In a rabatment the points are located by the intersection of two construction lines from the line of rotation (or ground line): one being the artist's line of sight (Centre) and the other, a construction line at 45° to the left (or the right).

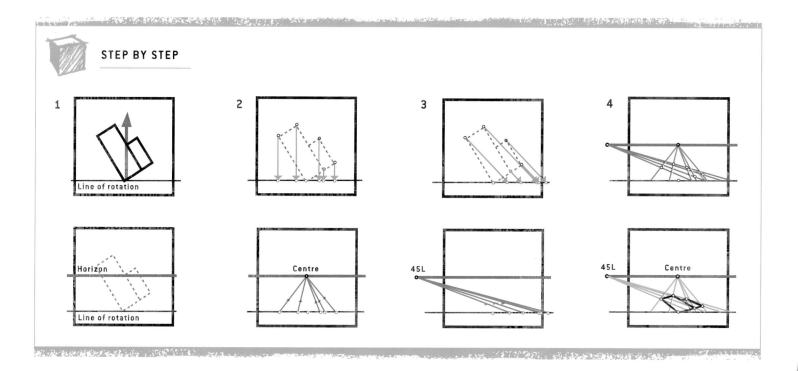

## The steps involved
## in rabatment

### 1. Marking out the plane

The plane is oriented, the strategic points are marked. The distance between the horizon line and the line of rotation gives the extent of the plane.

### 2. The screen with depth

Each point is projected to the ground line perpendicular to the line of rotation, then returns into the perspective space in accordance with the laws of perspective (towards the centre of the picture).

### 3. The screen in diagonal

Each point is projected to the ground line at 45° to the line of rotation, then returns into the perspective space towards point 45L.

### 4. Intersection of the information

The points are fixed in the perspective space at the intersection of the lines parallel to the line of sight and the lines at 45°.

# Principles to remember

The '45' points are directly linked to the artist's perception. These two reference points, which are always present in the field of vision, show the precise position of the artist and help him to develop his picture by giving the right angle measurement. The '45' points make it possible to establish the angle of vision and the diagonal of a square, to create the grid of a space and the rabatment of a plane.

Chios, Parparia

### The angle of vision

Provides information about the artist's visual field and the distance of observation.

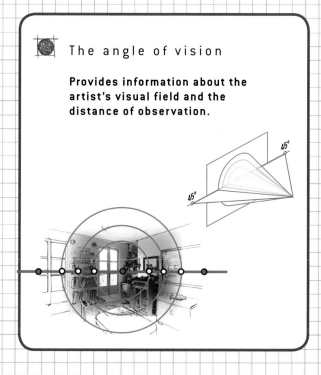

### Creating a grid for a space

A useful system for dividing a space into equal parts and locating the elements to be put in perspective.

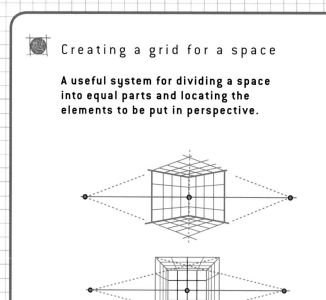

### The diagonal of a square

Makes it possible to have a scale in depth.

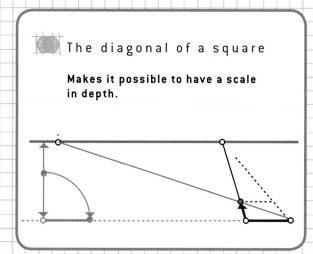

### Rabatment of a plane

Makes it possible to fix the points of a plane in a perspective space systematically.

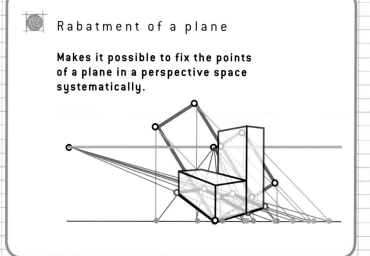

The artist is constantly surrounded by space where surfaces are not necessarily parallel or perpendicular to his view, but may correspond to oblique planes leading away in any direction from his field of vision. In conditions like this, many parallelopedic objects are easier to analyze with their own spatial logic, outside any pre-established three-dimensional context. And that is how the artist proceeds, instinctively re-transcribing the shapes around him one by one, like autonomous entities made of right angles, whose general orientation is undefined in relation to the gaze.

# Horizontal perspective

- Conditions of observation
- Reconstructing a right angle
- Multiple orientations
- Inclined planes
- Projecting a distance
- Calculating a dimension
- The photogrammetry approach

# CONDITIONS OF OBSERVATION

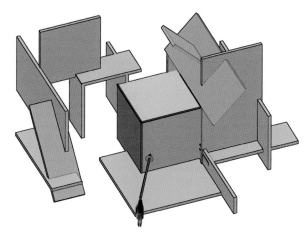

● The artist looks horizontally at a cube, which represents the synthesis of the space observed.

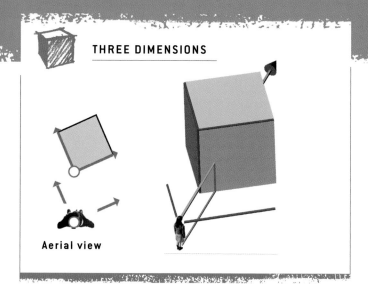

### THREE DIMENSIONS

Aerial view

● The principle orientations of space are represented by the edges of the cube.

● The artist looks towards the centre of the cube. His gaze is perpendicular to a flat transparent surface on which he 'traces' what he sees.

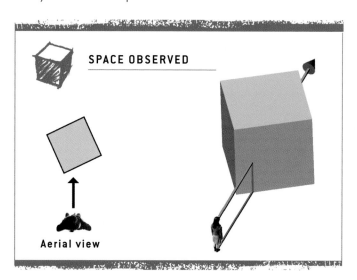

### SPACE OBSERVED

Aerial view

### GRAPHIC INTERFACE

Aerial view

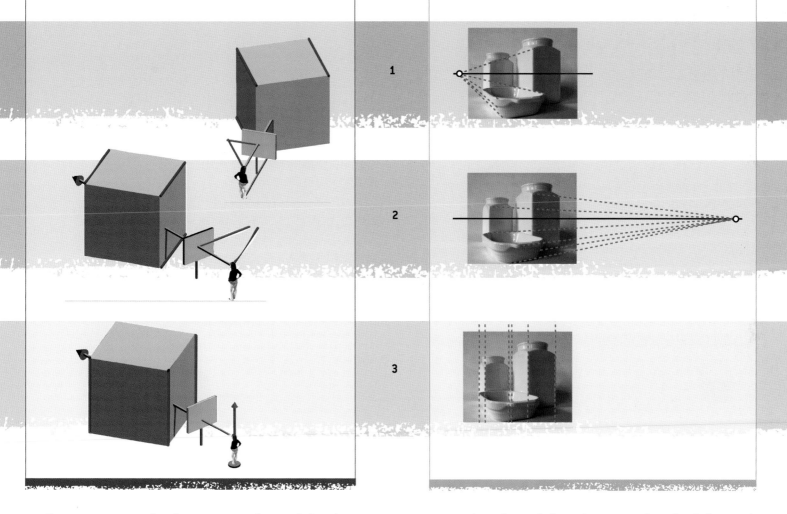

1

2

3

● The artist must make the viewer understand that he's in the presence of a cube, in spite of an orientation that's undefined overall. In his picture the construction lines on the right must match those on the left in order to recreate the feeling of a right angle.

● **1.** The edges of the cube oriented to the **left** vanish inexorably towards a point just to the left of the picture on the horizon line.
**2.** The edges of the cube oriented to the **right** all appear to lead to a distant point on the right of the picture.
**3.** The **verticals** appear to go from bottom to top of the picture, with no effect of perspective.

# RECONSTRUCTING A RIGHT ANGLE

● The artist must think of his picture like a window opening onto space. For any one direction in the space around him he must imagine a ray of light leaving his eye in that same direction and ending up on his picture, or to the side of it in an imaginary extension of the picture plane (since construction lines in space do not necessarily lead towards the picture). The point where the visual ray of light meets the picture plane will correspond to the vanishing point of the direction observed. This is true of every direction in the artist's environment.

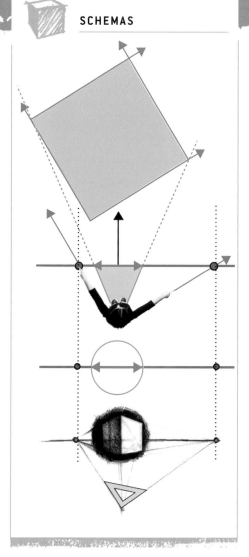

SCHEMAS

SCHEMA

In most cases the vanishing points are outside the drawing area.

● The vanishing points are an extension of the main construction lines of the space. The blue area in the schema above represents the cone of vision and the black arrow represents the artist's sight line, which is perpendicular to the picture plane. The size of this area depends on the size of the object and the distance of observation (see p.42).

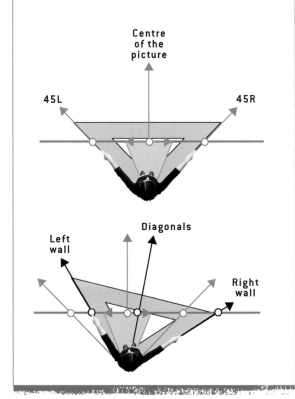

Centre
of the
picture

45L                                45R

Diagonals

Left
wall

Right
wall

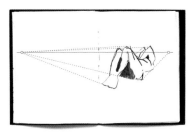

The axis of
the body and
the joints
represent two
construction lines
perpendicular
to each other.

 SCHEMAS

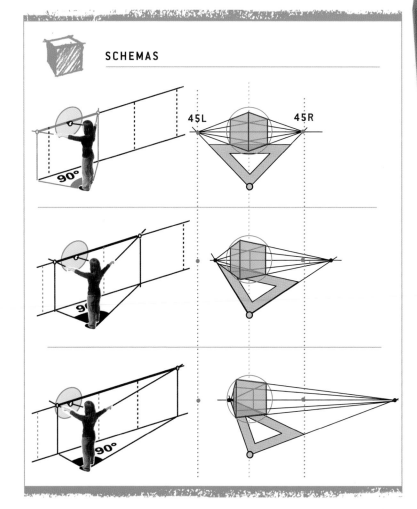

45L          45R

90°

90°

90°

● Construction lines 45R and 45L are directly linked to the artist's line of sight and represent fixed reference points in his field of vision. All other orientations follow a particular direction and give rise to new vanishing points.

● When the set square is rotated at an angle the new vanishing points (in black) do not constitute a simple translation of points 45L and 45R (in red), because an angular rotation has occurred. The closer one of them moves towards the centre of the picture, the further out of sight its perpendicular moves and ends up in the frontal plane.

# MULTIPLE ORIENTATIONS

● The vanishing point and line of sight must not be confused. Although the gaze is fixed in the centre of the picture, there are as many possible vanishing points as there are potential construction lines – an infinite number. The artist must determine the location of the vanishing points according to the construction lines of the objects in the space, and which azimuth corresponds to which vanishing point.

Man has an orthonormalized mental structure (left/right, front/back, up/down). When he looks at the horizon, the frontal plane and the sagittal plane together give rise to a multitude of orientations on a horizontal platform (see p.25).

**Horizontal perspective acts like a target – or a monitor screen – and each point on the horizon indicates a specific direction (the azimuth).**

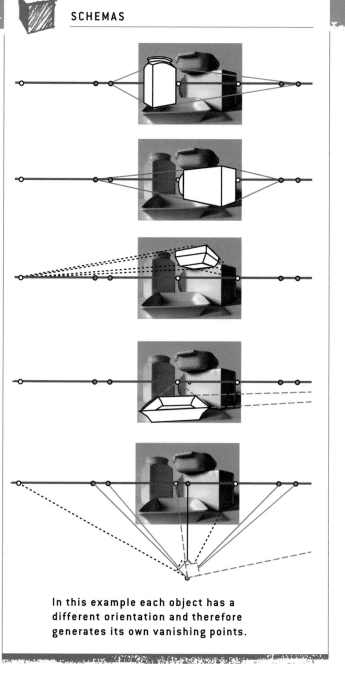

**In this example each object has a different orientation and therefore generates its own vanishing points.**

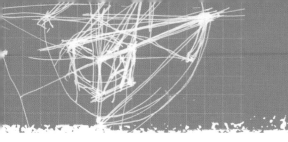

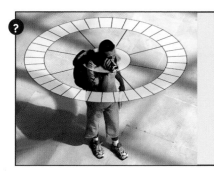

 **Azimuth:** the angle between two lines (one of which acts as a reference) on a horizontal plane around the observer.

## Finding the vanishing points of perspective

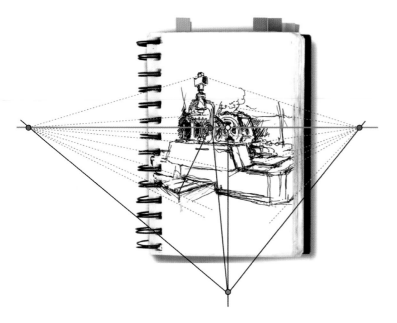

 **STEP BY STEP**

1. Define a drawing area.

2. Locate the centre and draw the horizon line.

Centre

3. Slide a set square along the edges of the picture following the angle of vision chosen (here 45°), keeping the gaze (E) perpendicular to the centre.

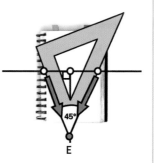
45°
E

4. Project two lines at right angles to each other. The red point in the centre marks the direction of the diagonal. It is of strategic importance because it makes it possible to define the diagonal of a square. It mustn't be confused with the line of sight (centre of the picture).

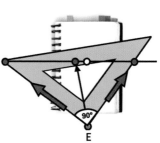
90°
E

63

# INCLINED PLANES

Slopes have a vanishing point vertical to their horizontal construction line.

Downward sloping and oblique lines follow a direction vertical to their orientation or azimuth (see p.62). This is what a geographer – or an astronomer – calls the height, the declination or the elevation. It's the same for an artist: an inclined plane (slope, staircase, roof etc.) leads to a vanishing point which is vertical to its orientation.

## Characteristics
## of an inclined plane

When drawing a slope or an incline we see that:
- The line of sight ends at the vanishing point C (centre).
- The orientation of the slope ends at the vanishing point V (vanishing).
- The elevation of the slope ends at the vanishing point $V^{+a}$ (V plus angle a).

**Elevation:** a vertical angle that creates a given construction line in relation to the horizontal.

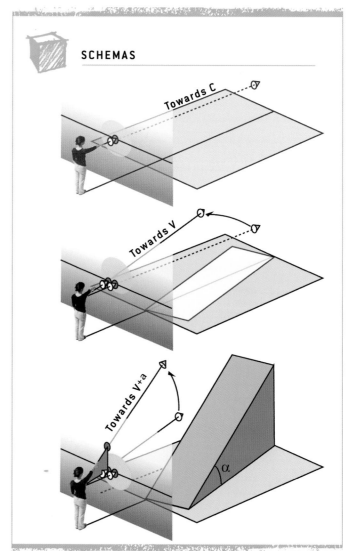

SCHEMAS

Towards C

Towards V

Towards $V^{+a}$

$\alpha$

# Locating the vanishing point

In this example the artist wants to find the slope elevation, that is the position of V⁺ for a precise value , for any orientation of the slope (or azimuth).

The starting conditions are as follows:
The line of sight (C) is known.
An angle of vision (45L) is chosen.
A slope orientation (V) is determined.

● 1. Find the distance between the observer (E) and the orientation of the slope (V).

● 2. Rotate this distance (E-V) on horizon line (E').

● 3. Point V⁺ is perpendicular to vanishing point (V) measuring angle  from point E'.

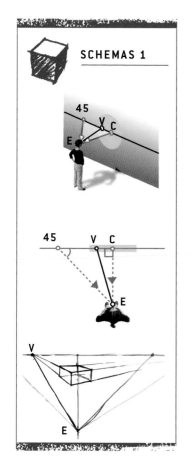

SCHEMAS 1

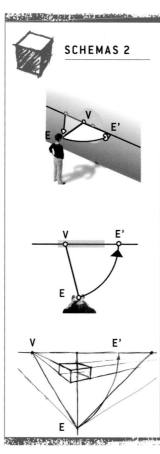

SCHEMAS 2

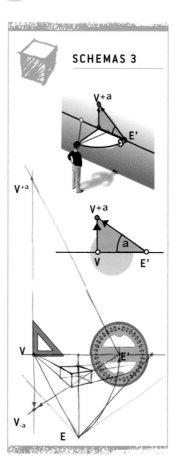

SCHEMAS 3

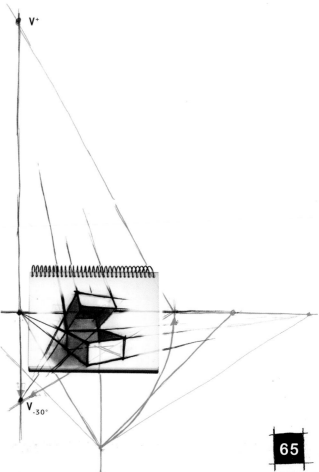

65

# PROJECTING DISTANCE

To break up a surface or increase the number of elements in a scene, an artist must be able to divide or project distances in a picture. This cannot be done just using a graduated ruler, and in fact it can be a real headache because of the exponential nature of perspective. So he has to turn to different geometrical approaches (see pp. 134-135) to project a distance in a picture.

Here are three different approaches the artist can use to achieve the same result. His choice will depend on the elements already in place in his drawing, or the rationale he feels is best suited to the space he's looking at.

(see pp. 134-135)

**Principle of division aerial view**

## PROJECTING DISTANCE USING A FRONTAL MEASUREMENT

1. **Insert distance A in a "corridor" leading to a point on the horizon.**

2. **Take a frontal measurement (parallel to the horizon) using a distance that will give a scale that's easy to find.**

3. **Project the distance in accordance with the frontal measurement to obtain more 'corridors' in the same direction as the first one.**

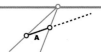

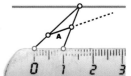

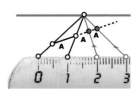

### DISTANCE TO BE CONTINUED

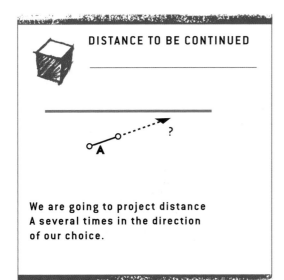

**We are going to project distance A several times in the direction of our choice.**

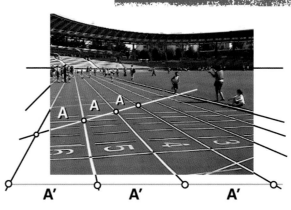

The artist must imagine corridors juxtaposed in a frontal plane (their direction is not important). The extension of the segment to be projected will cut across each corridor according to the same distance in reality.

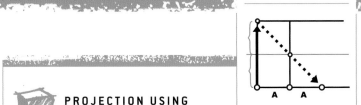

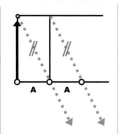

## Principle of division aerial view

## PROJECTION USING GEOMETRIC DIVISION

Project line A to the horizon and use it to form part of a vertical face.

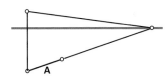

2. Divide the face into two parts of equal height.

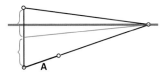

3. Multiply the first rectangle using the intersection half way up.

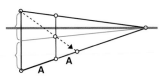

4. Repeat the operation as many times as necessary.

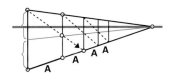

## Principle of division aerial view

## PROJECTION USING THE LINE OF THE DIAGONALS

1. Project line A to the horizon and use it to form part of a vertical face.

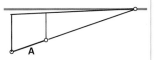

2. Draw the diagonal of the first rectangle.

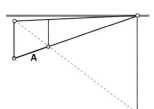

3. The identical rectangles that follow have diagonals parallel to the first which finish therefore at the same vanishing point vertical to their orientation (see p.64).

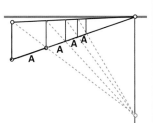

# CALCULATING A DIMENSION

## ■ The principle of vertical intersection

With perspective it is often difficult to calculate a measurement when it's no longer in the frontal plane. More often than not however, a simple vertical intersection will suffice and it's not absolutely necessary to resort to a laborious rabatment of the plane.

Since we know how to find the vanishing point of an incline, we can use the characteristics of a 45° angle to deduce measurements by vertical intersection following the process already used for the horizontal plane (see p.49).

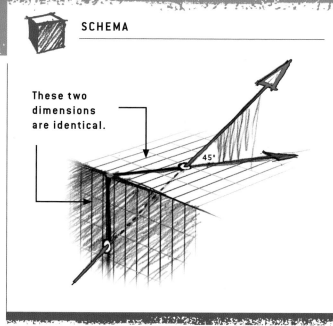

**SCHEMA**

These two dimensions are identical.

45°

● In the diagram on the left below, the intersection leads upwards (+45°) and vanishes towards a point we shall call 'V$^{+45}$', but a downward intersection is equally possible using the same process(-45°), when the vanishing point would then be 'V$_{.45}$'. The principles are exactly the same.

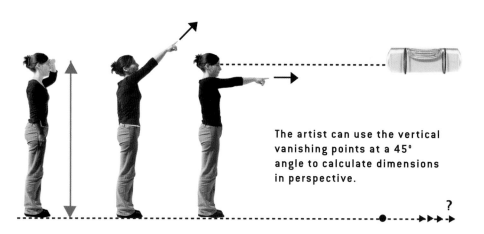

The artist can use the vertical vanishing points at a 45° angle to calculate dimensions in perspective.

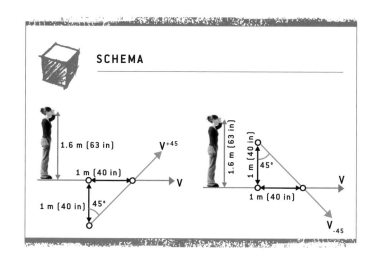

**SCHEMA**

1.6 m (63 in)
1 m (40 in)
V$^{+45}$
V
1 m (40 in)
45°

1.6 m (63 in)
1 m (40 in)
45°
V
1 m (40 in)
V$_{-45}$

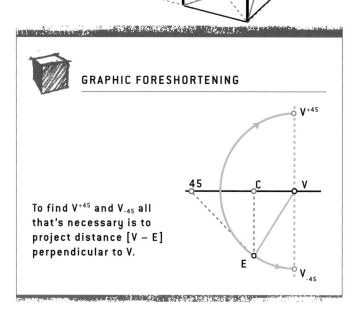

# Applying
## vertical intersection

To find vanishing points $V^{+45}$ and $V_{-45}$, which will make it possible to calculate any horizontal dimension using 45° vertical intersection, the artist will proceed using:

**1.** Deduction of the distance between him and the picture. This means finding point E using the centre of the picture (C) and a '45' point (grey line).
**2.** Rabatment of the distance (V – E) on the horizon line to find E' (blue line).
**3.** Drawing a straight line at 45° from E' to the vertical of V (red line).

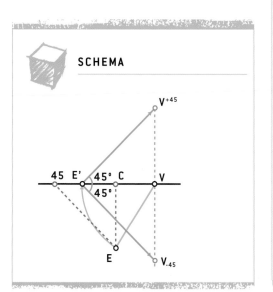

**SCHEMA**

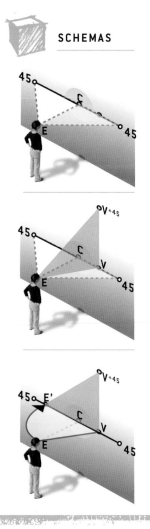

**SCHEMAS**

**GRAPHIC FORESHORTENING**

To find $V^{+45}$ and $V_{-45}$ all that's necessary is to project distance [V – E] perpendicular to V.

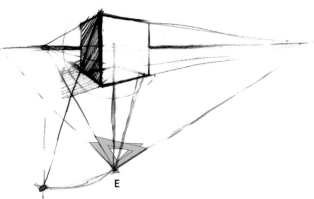

Points $V^{+45}$ and $V_{-45}$ make it possible to find a distance in any horizontal direction with certainty.

# THE PHOTOGRAMMETRY APPROACH

The following exercise, called photogrammetry, consists of starting with a photograph and drawing a reverse perspective resulting in a plane. This exercise can be useful for archaeological or specialist work. It enables an artist to practise 'from life', bringing him face to face with the fundamental principles governing most works of perspective. Studying a real situation (a photograph) makes it possible to dismantle the mechanisms of perspective that constitute the architecture of visual space (positioning of vanishing points, cone of vision etc.).

## Placing the horizon line

• Extend several horizontal lines which may in reality be parallel with each other.
• Deduce the horizon according to the vanishing lines. If the horizon is not horizontal it means that the camera was tilted when the photograph was taken. If this is the case, it must be straightened up before continuing.

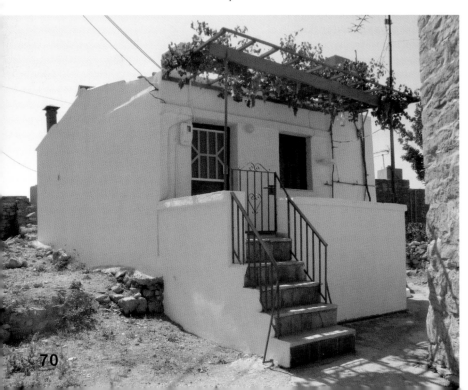

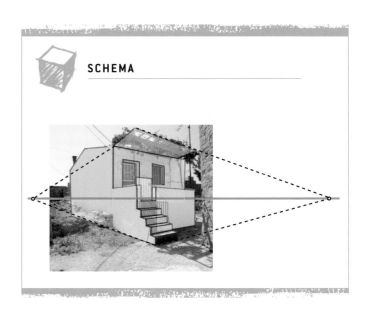

SCHEMA

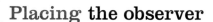

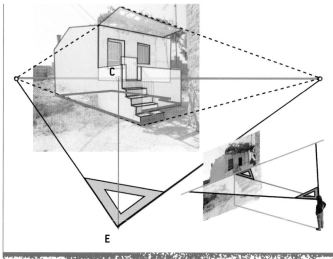

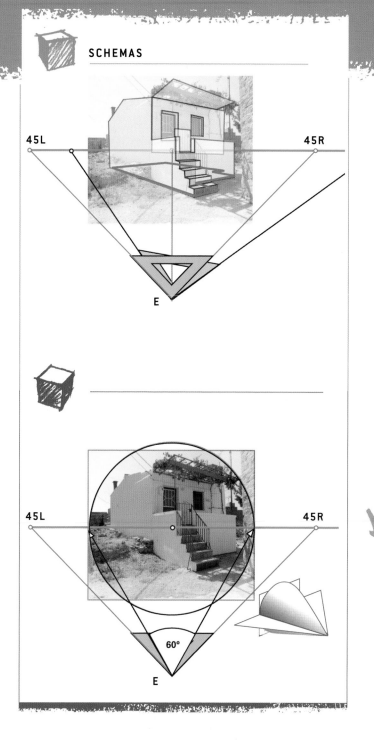

## Placing the observer

• Deduce the distance of observation (E) on the vertical of C (Centre) using two construction lines that may in reality be perpendicular to each other.

• Draw the plane. The centre of the photo should be on the horizon line. If this is not the case it indicates that the shot was taken from a high or a low angle.

## Placing points 45L and 45R

Plot points 45L and 45R (sliding the set square at 45° either side of E) in order to be able to execute the rabatment of the plane.

## Finding the angle of view

At this stage it's possible to find the angle of view (cone of vision) used to take the photograph (about 60° in this example). This angle is measured from E to the edges of the photo.

## Choosing a ground line

The distance at which frontal rotation (the ground line or line of rotation) is used will determine the scale of the plane. The nearer the rotation is to the bottom of the image the closer it is to the observer and the larger the plane will be. In this example we have placed the line of rotation arbitrarily in the middle of the plane of the house, which will give us 1.6 m / 63 in (horizon height) = line of rotation to horizon distance.

## Projecting the points

Each point is extended to the line of rotation according to two construction lines, or more accurately, from two vanishing points since we are on the horizontal plane. These are C (blue) and 45L or 45R (red). The reference points thus found on the line of rotation – which is a straight line common to both planes – will act as a basis for determining the intersection on the vertical plane according to the same construction lines: perpendicular to the line of rotation and therefore systematically vertical (blue) and inclined at 45° (red).

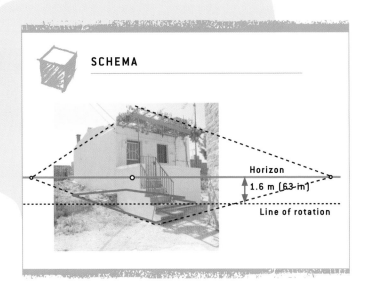

**SCHEMA**

Horizon
1.6 m (63 in)
Line of rotation

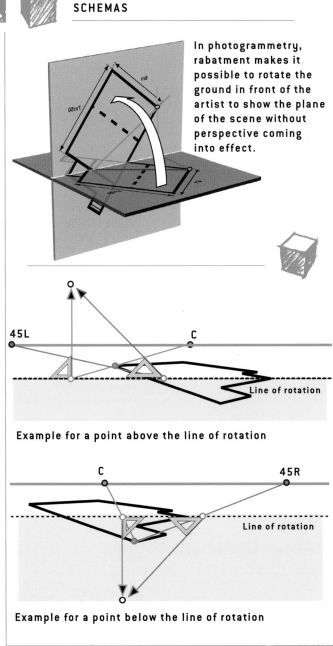

In photogrammetry, rabatment makes it possible to rotate the ground in front of the artist to show the plane of the scene without perspective coming into effect.

45L    C

Line of rotation

**Example for a point above the line of rotation**

C    45R

Line of rotation

**Example for a point below the line of rotation**

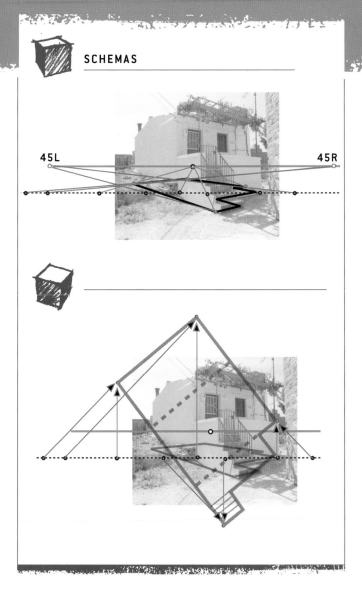

45L          45R

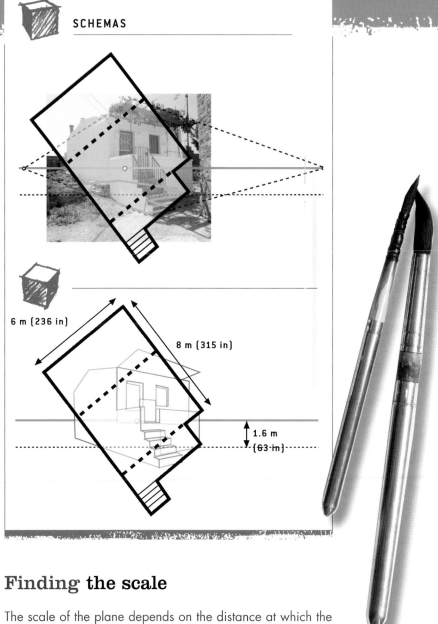

6 m (236 in)

8 m (315 in)

1.6 m
(63 in)

## Assembling the plane

The operation just described can be used for all points. The task can be systematized by first extending them all to the line of rotation before finding where they intersect in the frontal plane.

## Finding the scale

The scale of the plane depends on the distance at which the imaginary sheet of glass has been placed (the line of rotation), and on the presumed height of the horizon. Here it is at the photographer's eye level (1.6 m / 63 in).

# Principles to remember

In a horizontal perspective the first and most important task is to note the orientation of each construction line in space and find its corresponding vanishing point. Once the orientations and construction lines have been determined, the space must be measured and punctuated by intersections of construction lines and geometric subdivisions.

*The studio in rue Pigalle*

## Multiplicity of vanishing points

When the artist looks towards the horizon, each construction line in space generates its own vanishing point.

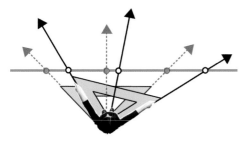

## Projecting a distance

**A distance can be projected, multiplied or divided by using:**

- A measurement in the frontal plane.

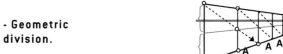

- Geometric division.

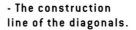

- The construction line of the diagonals.

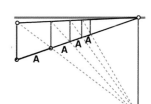

## Inclined planes

**The vanishing point of an inclined plane ends on the vertical of its construction line.**

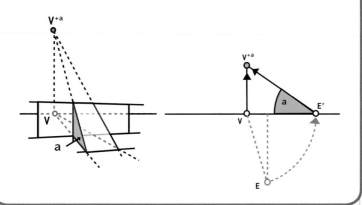

## Calculating a dimension

**A dimension can be calculated using a vertical intersection at 45°.**

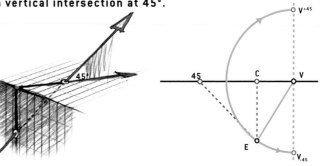

As the dimensions of a subject to be drawn decrease in size, the eye tends to move away from the horizontal and may even end up with a distinctly downward viewpoint.

For example, it's very likely that your gaze is not horizontal as you read this book. It's probably nearer to the vertical, and the same applies to our observation of most objects around us.

When the artist's gaze leaves the horizontal, the verticals are subject to an effect of perspective effect for the same reason as the horizontals. The picture will then follow the same logic as space – a three-dimensional logic.

# Three-dimensional
# perspective

- Conditions of observation
- Three-dimensional organization of space
- Locating vanishing points
- Harmonizing vanishing points
- The notion of verticality

# CONDITIONS OF OBSERVATION

We must bear in mind that positioning of vanishing points is mainly dictated by the organization of space once the artist's line of sight has been determined. There will therefore be three vanishing points for any three-dimensional space (width, depth and height), symbolized here by a cube.

● The observer looks at a cube oriented at an angle.

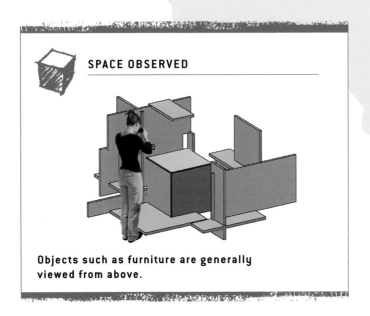

**SPACE OBSERVED**

**Objects such as furniture are generally viewed from above.**

● As the gaze is not directed towards the horizon the perspective is described as 'downward'. Objects are seen partly from above.

● The observer looks down at an angle of sight of around 22.5° to the horizontal.

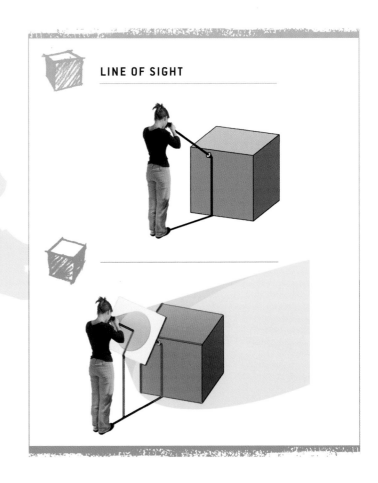

**LINE OF SIGHT**

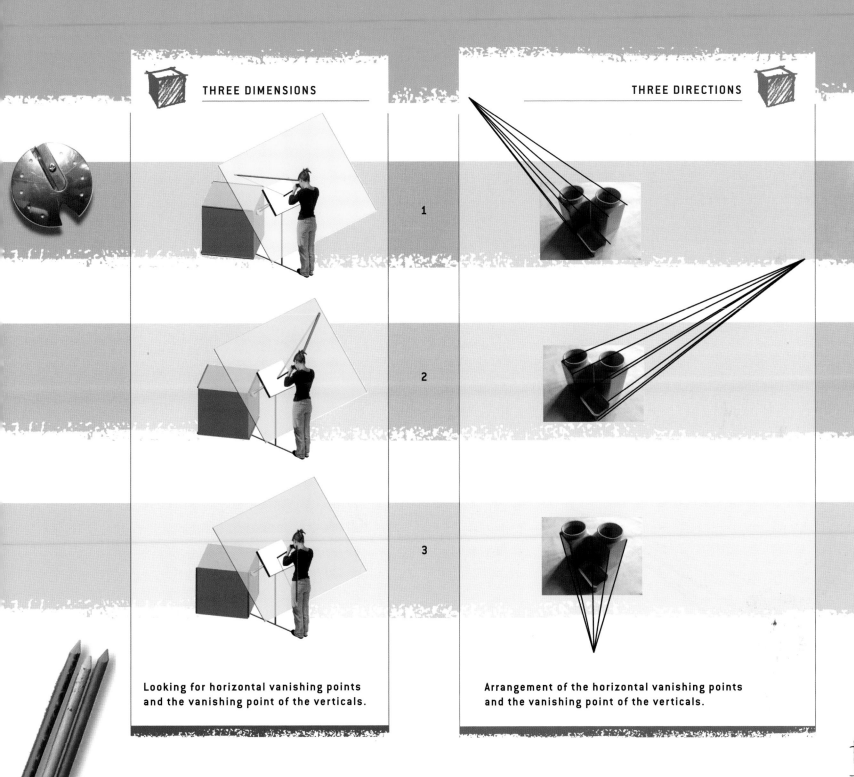

1

2

3

Looking for horizontal vanishing points
and the vanishing point of the verticals.

Arrangement of the horizontal vanishing points
and the vanishing point of the verticals.

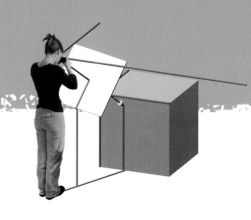

# THREE-DIMENSIONAL ORGANIZATION OF SPACE

● The main construction lines of space that the observer sees do not necessarily go across the drawing area. Nevertheless they must be positioned in the same way as points 45L and 45R. It is possible to show exactly where the construction lines lead by extending the drawing area to a wider plane.

In the diagram opposite the artist's horizon is above the drawing area (dark blue area, indicated with a blue line underneath). Its vertical is below the drawing area. The artist will have to position the three vanishing points (horizon left, horizon right and vertical) in relation to the centre of the drawing.

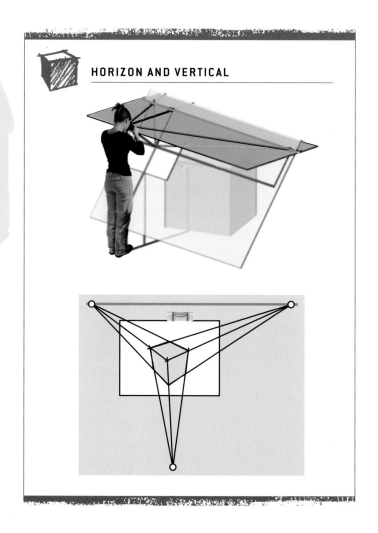

**HORIZON AND VERTICAL**

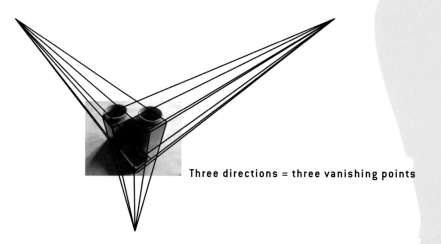

**Three directions = three vanishing points**

 **C** = Centre [of the gaze and the picture]
**V** = Vertical [of the eye and the picture]
**E** = Eye [on the horizontal plane]
**L** = Left
**R** = Right

## The artist's situation

By analysing the scene from the side it is possible to deduce:
• The distance between the centre of the picture and the vanishing point of the verticals (1).
• The distance between the centre of the picture and the horizon line (2).
• The distance between the artist and the horizon of the picture (3).

 SCHEMAS

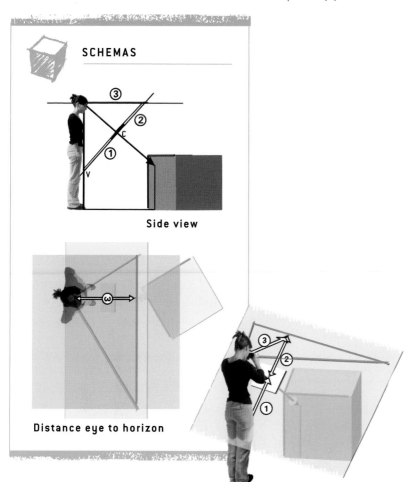

Side view

Distance eye to horizon

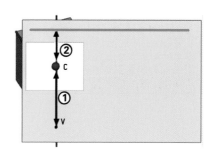

**Drawing area as seen by the artist.**

The position of the vanishing points on the horizon must be established in relation to the distance from the eye to the horizon (3), which varies depending on the slope of the gaze and the picture.

**Eye to horizon distance rotated on the drawing.**

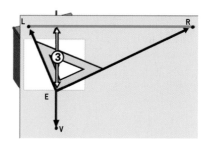

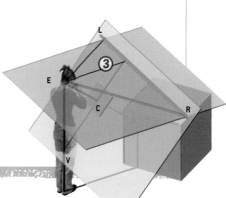

# LOCATING
# VANISHING POINTS

Here we're going to go back and forth between the artist's spatial position and his picture plane. First we shall observe the artist's line of sight from above and from the side to determine, on the picture plane, where the main construction lines of space end.

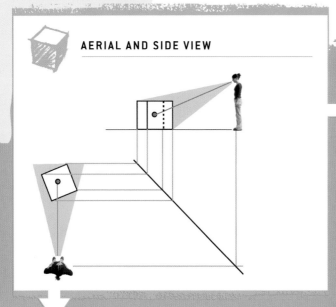

**AERIAL AND SIDE VIEW**

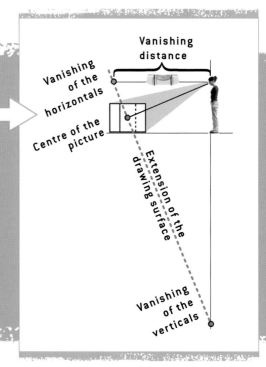

Vanishing distance

Vanishing of the horizontals

Centre of the picture

Extension of the drawing surface

Vanishing of the verticals

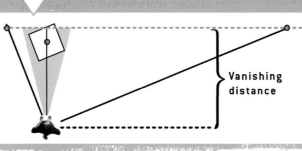

Vanishing distance

## OUTWARD

The side view (red in the schemas) gives us the vanishing point of the verticals and the position of the horizon line. The aerial view (blue in the schemas) gives us the left and right vanishing points.

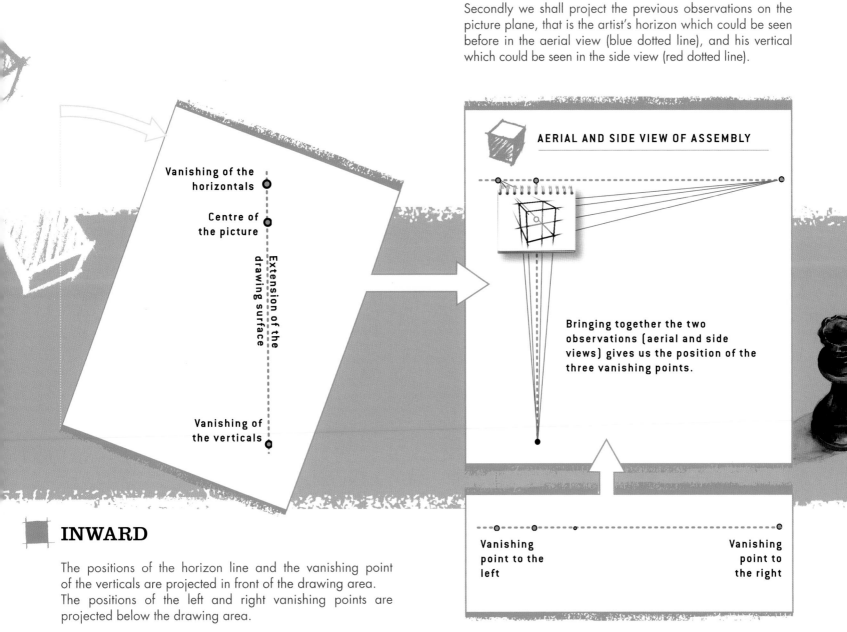

Secondly we shall project the previous observations on the picture plane, that is the artist's horizon which could be seen before in the aerial view (blue dotted line), and his vertical which could be seen in the side view (red dotted line).

Vanishing of the horizontals

Centre of the picture

Extension of the drawing surface

Vanishing of the verticals

**AERIAL AND SIDE VIEW OF ASSEMBLY**

Bringing together the two observations (aerial and side views) gives us the position of the three vanishing points.

Vanishing point to the left

Vanishing point to the right

## ▉ INWARD

The positions of the horizon line and the vanishing point of the verticals are projected in front of the drawing area.
The positions of the left and right vanishing points are projected below the drawing area.

## In practice

This exercise puts the aforementioned ideas (outward-inward between space and drawing) into practice and enables the three vanishing points of a perspective to be located.

The artist has chosen to draw a metre rule on a table. He will determine precisely where the vanishing points of his perspective are in eight steps using a simple schema drawn freehand.

During the course of the exercise he must represent the scene (himself looking at the object) viewed from the side (steps 1 to 4) and then from above (steps 5 to 7). The final schema shows the last drawing of the rule with the three vanishing points.

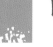
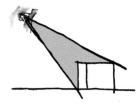

**1. Define the cone of vision (that is the overall angle at which the object will be viewed) to determine the distance at which to position yourself in order to represent it accurately.**

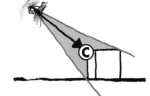

**2. Draw the visual ray aimed at the centre of the object to be drawn (and therefore the centre of the picture).**

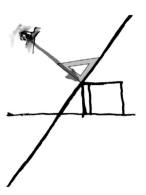

**3. Place an imaginary drawing surface perpendicular to the central visual ray. This is like a transparent surface on which the virtual object will be traced. Remember that the place where this line (perpendicular to the gaze) is positioned will not change the perspective, only the scale factor.**

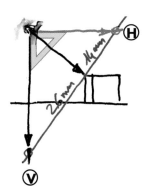

**4. Mark the centre to horizon and centre to vertical distances directly on the drawing. This gives the measurements from the vertical axis with the distances between the horizon, the centre and the vanishing point of the verticals. Now it remains to locate the vanishing points of the left and right faces of the object (steps 5 to 7).**

5. Draw the scene from above using the side view to help you (the drawing is done below and on the same scale).

6. Make the observer to horizon distance 14 mm correspond on the aerial view of the scene.

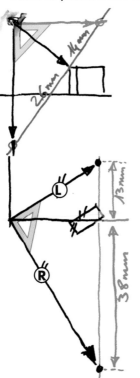

? Horizon **H**
Verticality **V**
Centre **C**
Left **L**
Right **R**

7. Determine the position of the horizontal vanishing points on the horizon line (aerial view) by following the construction lines of the object's faces from the observer (see p.81). Thus we obtain the horizontal axis with the distance between points L and R.

8. Then project the two axes (vertical and horizontal) on the drawing area from the centre of the image (C) starting with points V and H of the vertical (red) and continuing at H with points L and R of the horizontal (blue).

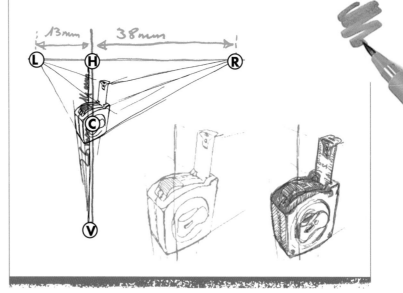

The exercise is the same for a small object viewed close-up, a medium sized object seen from a few metres away or an architectural grouping viewed from a distance.

## Superimposing views

This is a simplified drawing that makes it possible to find the principal vanishing points of a given spatial situation quickly. The aerial view analysis is superimposed on the side view analysis to give instant positioning of the three vanishing points. Location of the three vanishing points is immediate. A vanishing point of the horizontal diagonals has been added, keeping to an angle of 45° from the right (or the left). This makes it possible to draw the bottom and top of the cube (diagonal of a square).

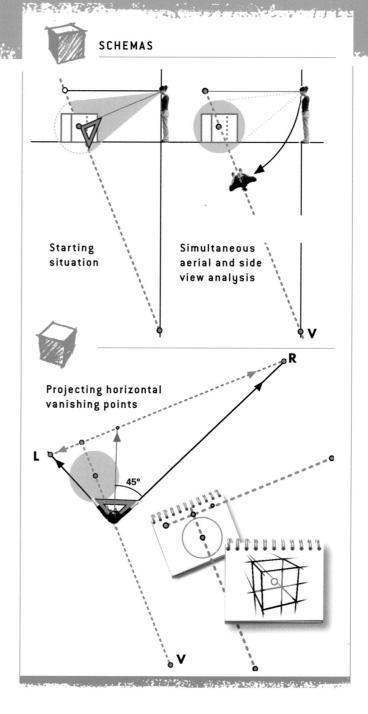

**SCHEMAS**

Starting situation

Simultaneous aerial and side view analysis

Projecting horizontal vanishing points

45°

L

R

V

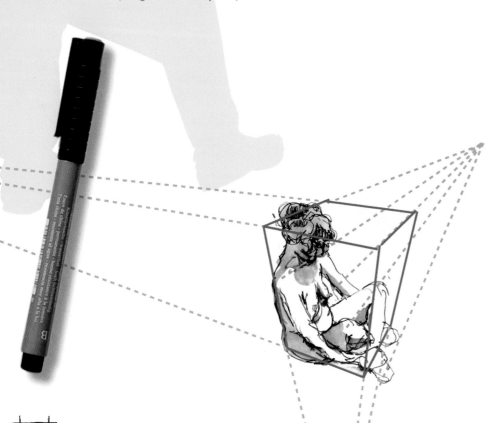

# Diagonals

When the three vanishing points are fixed they can be taken two at a time to determine the diagonals. All that's needed is to find on each height of the triangle of equilibrium the point that makes a right angle with the base and then to draw the bisector from this point.

**SCHEMAS**

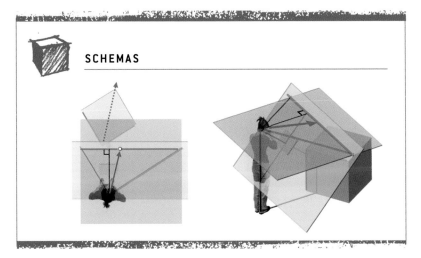

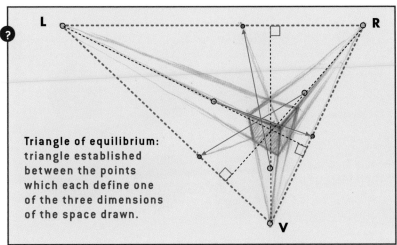

**Triangle of equilibrium:** triangle established between the points which each define one of the three dimensions of the space drawn.

**SCHEMAS**

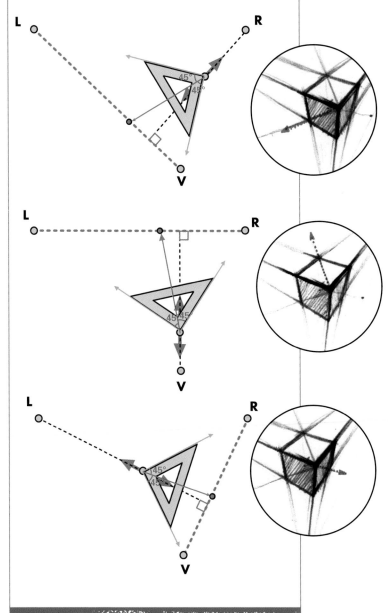

# HARMONIZING VANISHING POINTS

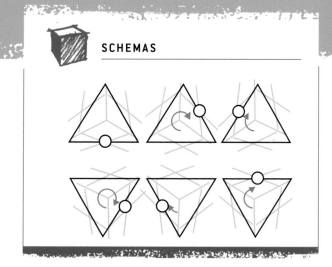

## Comparative exercise

● As the view moves up or down the vanishing point of the verticals moves nearer to the centre of the picture, while the horizon recedes. The left and right vanishing points move further apart on the horizon.

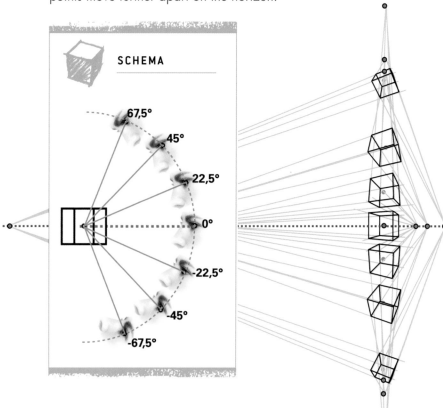

SCHEMA

67,5°
45°
22,5°
0°
-22,5°
-45°
-67,5°

● Unlike horizontal perspective, three-dimensional perspective will always look right whatever the orientation of the drawing. You only have to place one of the sides of the triangle of equilibrium horizontally to simulate a horizon (six possibilities). The opposite vertex gives a sense of falling or rising perspective depending on whether it's above or below the horizon.

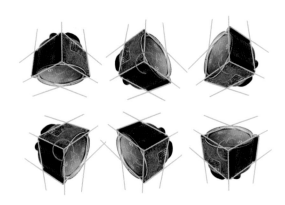

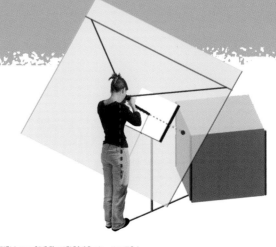

## Placing the vanishing points

The three vanishing points of a perspective cannot be chosen at random, because together they maintain a three-dimensional balance based on the right angle. They can, moreover, be positioned in relationship to each other. The aim of the following exercise is to position the three vanishing points of a three-dimensional perspective harmoniously, in accordance with the artist's field of vision, his line of sight and the spatial situation surrounding him (horizon, centre of gravity).

● 1. Choose the field of vision and draw the horizon
Fix two known vanishing points (see p.44), then draw the horizon either inside or outside the drawing area. This will show where the field of vision is in relation to the horizon.

● 2. Position the observer and draw the horizontal construction lines
The distance of the observer in relation to the horizon is the same as the distance in relation to 45R (this analysis is shown in aerial view). From the observer (E), draw two horizontal construction lines at right angles (see p.81).

● 3. Find the centre of gravity
As the top of each triangle of equilibrium is perpendicular to the opposite side and also in alignment with the centre, the third vanishing point can be deduced in relation to the first two.

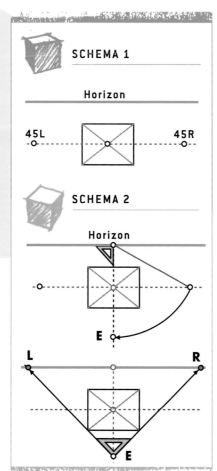

SCHEMA 1

Horizon

45L            45R

SCHEMA 2

Horizon

E

L            R

E

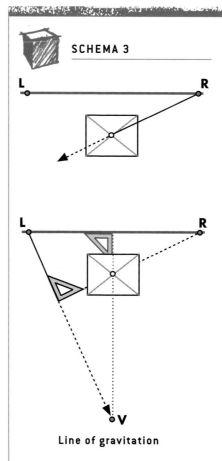

SCHEMA 3

L            R

L            R

V

Line of gravitation

If the horizon is no longer exactly in the centre of the picture a horizontal perspective is no longer relevant. A vanishing point of the verticals will inevitably appear.

# THE NOTION OF VERTICALITY

 **Surface and** gravitation

● An artist must show the spatial data he shares with all observers in his picture:
– the earth's surface (horizontal plane).
– the gravitation (vertical axis).
He can then give his viewpoint (line of sight, visual field).
All the notions in the chapter on horizontal perspective are true for three-dimensional perspective. Only the notion of **verticality** changes. In a three-dimensional perspective the **verticals** all lead to the same vanishing point represented by the direction of gravitation experienced by the artist himself. The verticals in the space are all parallel to each other, including the artist's vertical. As, by definition, he faces the centre of the picture, the vanishing point of the verticals he sees is vertical to that centre.

● In the example opposite the three points R+60°, R and R-30° are vertical to each other because they have the same orientation (see Inclined Planes, p.64). So they are on the same straight line leading to the vanishing point of the vertical axis (V).

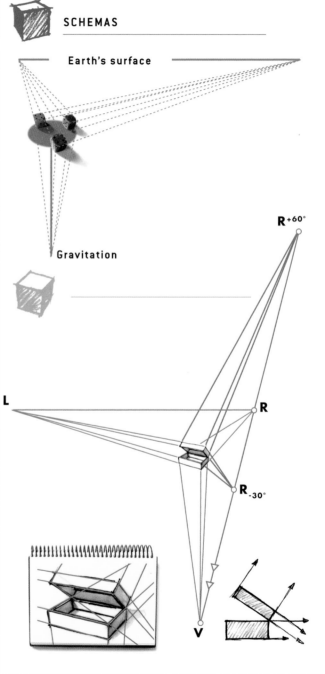

SCHEMAS

Earth's surface

Gravitation

R+60°

L

R

R-30°

V

## Looking up and down

To suggest an upward or downward gaze the artist must change the position of the vanishing point on the vertical axis. When the point is below the horizon it indicates that the artist is looking down. When it's above, it indicates that he's looking up.

**SCHEMAS**

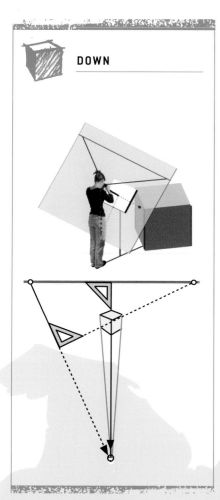
**DOWN**

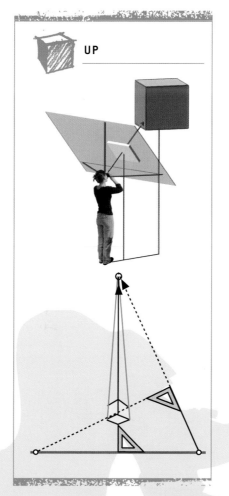
**UP**

## Looking left and right

The artist tilts the horizon to suggest a turning of the head to left or right. This often happens with rising or falling views where framing moves away from the horizontal and gives way to notions of legibility and composition. Tilting of the horizon forces the viewer to tilt his head spontaneously to find his bearings in the picture, thus reinforcing the sensation of looking up or down.

# Principles to remember

Three-dimensional perspective provides a response to the question: 'What is my line of sight in a horizontal context subjected to gravity?'. So the artist must define the vertical axis and the horizontal plane. He must then find size references and place them in a three-dimensional triangle of equilibrium.

*Valissos, Chios Island*

## The vertical axis

Side view analysis of a scene makes it possible to find the horizon and the vanishing point of the verticals.

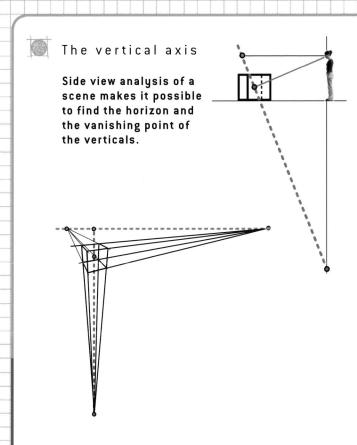

## The horizontal plane

Aerial view analysis of a scene makes it possible to determine the vanishing lines of the horizontal plane.

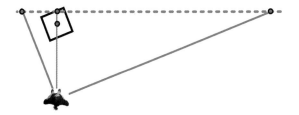

## The diagonals

By referring to secondary vanishing points (the diagonals), it is possible to get an idea of relative sizes (depths).

## Harmonization of vanishing points

• Each of the three vanishing points shows a dimension of space. Together they form a triangle of equilibrium based on the right angle.
• The vanishing point of the verticals is always vertical to the centre of the picture.
• The other two vanishing points define the horizon.

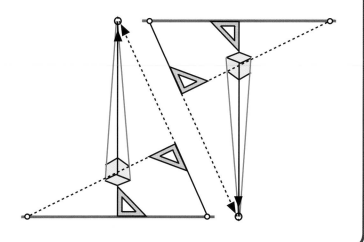

# Choices of
## perspective

An artist has to respond to the spatial situation in front of him, compromising between graphic effectiveness and visual credibility. Small objects will be treated differently from furniture and open spaces will not have the same requirements as buildings.

- **Small objects**
- **Medium-sized objects and figures**
- **Outdoor scenes**
- **Indoor spaces**

# SMALL OBJECTS

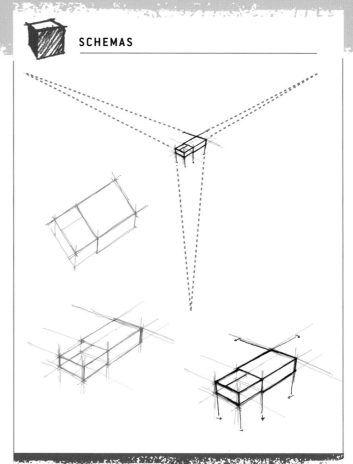
● Objects are viewed from a distance of at least 40 centimetres, no matter what their size. A small object like a box of matches will take up very little space in the artist's field of vision. Viewed at an angle of no more than a few degrees, it will display very little distortion caused by perspective (see p.15).

Because of this laborious construction with vanishing points outside the drawing area would give a scarcely visible result, in that identical construction lines would be almost parallel.
So most of the time axonometric projection is enough for the basic construction of small objects. If necessary, perspective can be expressed through subtle shrinking of the parts furthest away.

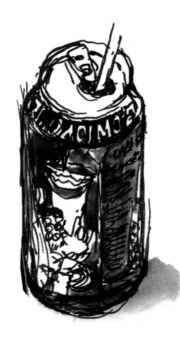

**A credible perspective drawing starts with reasonable conditions of observation.**

# Axonometric **codes**

Parallel perspective and architectural perspective are two specific types of axonometric coding.

● **Parallel perspective** is characterized by frontal (therefore not distorted) representation of one face of an object and parallel projection of the other faces. The orientation of the projection differs according to use. The dimensions can be reduced, increased or kept at their actual size. This type of perspective is often projected at a 45° angle reducing depth by half.

● **Architectural perspective** (also called military, iso-parallel or even 'axono' perspective) is created by orthogonal representation of a plane and vertical projection of the elevations on one scale. The orientation of the plane is arbitrary. Its projection allows measurements to be taken on the same scale on the three axes.

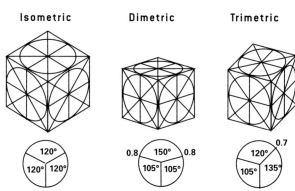

**AXONOMETRIC PROJECTIONS**

Isometric  Dimetric  Trimetric

The circles show how to interpret the axonometric projections: the three angles of projection are shown inside and their coefficient of enlargement (when it is not equal to 1) is given outside.

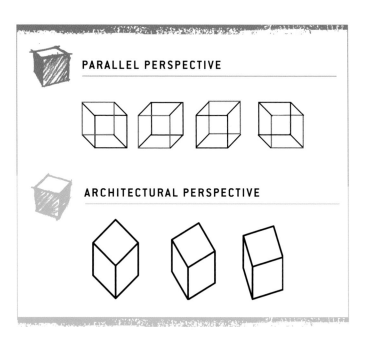

**PARALLEL PERSPECTIVE**

**ARCHITECTURAL PERSPECTIVE**

**?** **Axonometry:** two-dimensional representation of an object or space whose three dimensions are each projected on a normed axis and therefore do not display any perspective shrinking. There are typically three types of axonometric code: **isometric**, where all the angles are equal, **dimetric**, with two different angle relationships and **trimetric**, with three different angle relationships.

# MEDIUM-SIZED
# OBJECTS AND FIGURES

● Triangulation of vanishing points must be used to represent furniture, large household appliances or figures in close-up. The vanishing point of the verticals stays perpendicular to the centre of the picture since it represents the vertical of the artist who is himself facing the centre of the picture.

● The higher (or lower) the point from which the object is viewed, the closer the vanishing point of the verticals moves to the centre of the picture, whereas the horizon line and the vanishing points on the horizon move away from it.

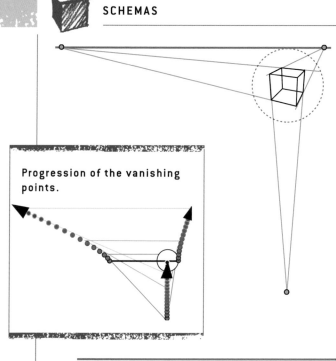

**Progression of the vanishing points.**

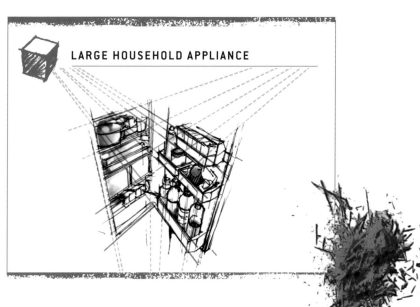

**LARGE HOUSEHOLD APPLIANCE**

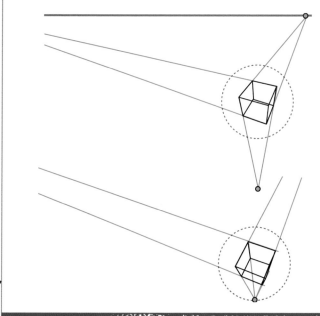

## FIGURE

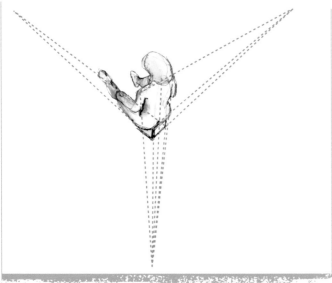

In our everyday space most pieces of furniture are on our horizon line. The ground is present everywhere and anchors the elements in the picture by defining their base. It's also a plane of reference for both the artist and the furniture. The perspective is described as downward, as the eye looks down towards the ground.

The construction of figures in close-up is based on a three-dimensional perspective taking into account the ground line and a vertical equilibrium.

## FURNITURE

# OUTDOOR SCENES

In outdoor scenes the subject of the picture and the area of visualization are clearly defined. The edges of the picture usually correspond to the edges of the scene observed.

## ■ Dominant **horizontal** character

The horizon remains visible, the verticals do not vanish.

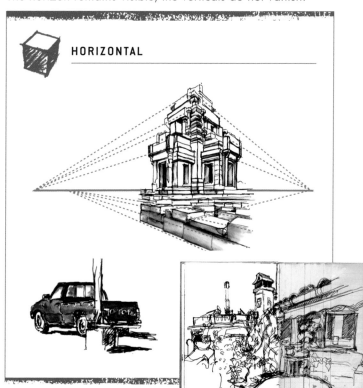

HORIZONTAL

## ■ Dominant **vertical** character

A vertical vanishing point appears. Figures take up much of the space and are subject to the vertical nature of the image.

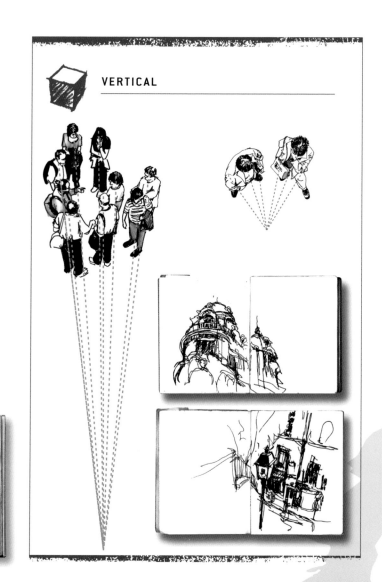

VERTICAL

## Ascending slopes

Upward slopes must be treated like rising perspectives so they do not overfill the image and allow what is beyond to be seen. In the scene opposite, the central point of the image (red) is half way between the vanishing line of the slope and the horizon.

## Descending slopes

Downward slopes can be treated like views with a dominant horizontal or vertical characteristic depending on whether the observer is on the slope or beyond it.

In this sketchbook the same sloping street has been drawn twice.

The sketch on the left was drawn from a horizontal perspective on the slope itself: the image is centred on the horizon (blue line).

The sketch on the right was drawn in three-dimensional (falling) perspective from a viewpoint this side of the slope: the image is then centred on the vanishing line of the slope (red line).

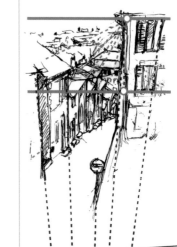

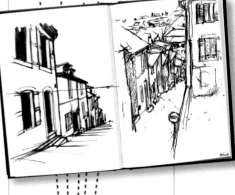

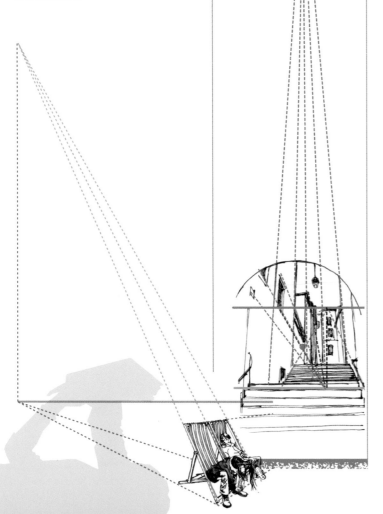

# INDOOR SPACES

An indoor space extends beyond the artist's field of vision. It is only ever one part of a space that can be sensed, enclosed on all sides by walls that rarely allow a glimpse of distant horizons.

## Dominant horizontal **character**

The vanishing points are on a horizontal axis towards the centre of the picture.

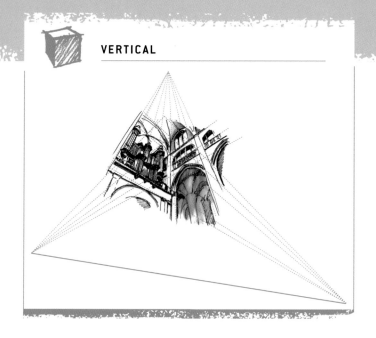

**VERTICAL**

## Dominant **vertical** character

Although the horizon is completely absent from the picture it acts as a reference point and indicates the angle of the composition.

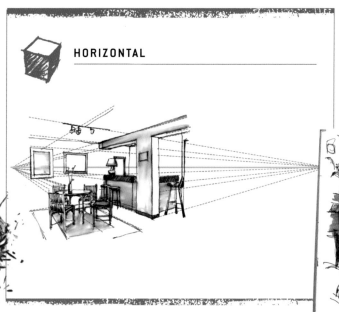

**HORIZONTAL**

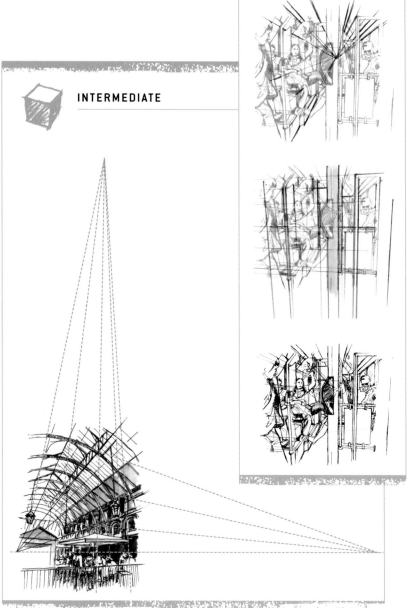

INTERMEDIATE

## Intermediate scenes

The horizon can be seen in the drawing but is not in line with the centre. A vanishing point of the verticals then inevitably appears (see p.89). This type of scene should therefore be treated like a three-dimensional perspective. However the distance of the vanishing point of the verticals is such that foreshortening on this axis is negligible. The views are half-rising or half-falling.

# Principles
# to remember

We experience very different spatial situations in our lives which cannot be treated using an identical or systematic drawing process because they engage our bodies and eyes in different ways. Here we have looked at four general types of visual situation an artist will encounter.

*Villa Phoebus, Saint-Brévin l'Océan*

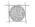

## Small objects

Under normal conditions of observation small objects are scarcely subject to perspective. In most cases the use of axonometric projection is better.

## Outdoor scenes

- The gaze is generally horizontal.
- The vanishing points converge on the horizon, which is towards the centre of the picture.

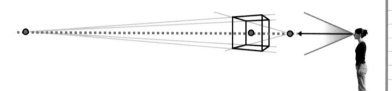

## Medium-sized objects, figures

- The vanishing point of the verticals is relatively close to the drawing area and often visible in the picture.
- The horizon is distant from the centre and rarely situated in the picture.

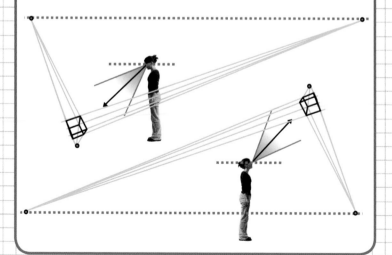

## Indoor spaces

- The vanishing point of the verticals (if there is one) is a long way from the drawing area.
- The horizon is generally visible in the picture, often near the centre.

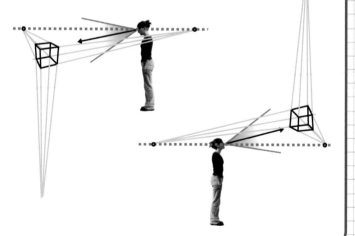

# Ellipses, shadows and reflections

Ellipses, shadows and reflections cannot be ignored in perspective. The artist has to maintain the balance of the geometric shapes, show how the light – without which nothing would be visible – falls, and establish a coherence between the real and virtual spaces of reflective surfaces.

■ **Ellipses**

■ **Shadows**

■ **Reflections**

■ **An example in three-dimensional perspective**

# ELLIPSES

A circle in perspective in the centre of a picture, without distortion (see p.16), is an ellipse. It's a good idea to practise drawing an ellipse freehand before you start to construct a circle in perspective, because if you can draw an ellipse you can draw a circle. Drawing a circle in perspective shows a perception of space by demonstrating the artist's ability to manage width, depth and the diagonal at the same time. We're now going to study different ways of drawing an ellipse and a circle in perspective.

**?** **Ellipse: a flat curved line for which the sum of the distances from each point in relation to two fixed points (the foci F and F') is constant. An ellipse is different from a circle in that it has two axes of different lengths: the minor axis (red) and the major axis (blue).**

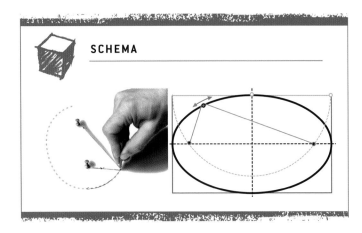 

SCHEMA

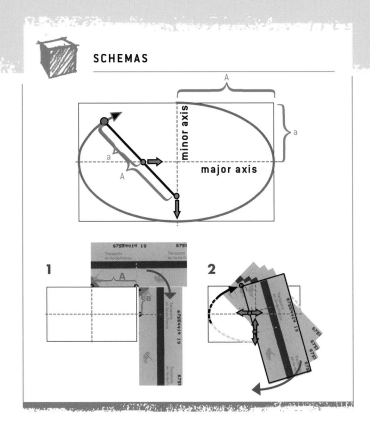

SCHEMAS

## Drawing an ellipse by rotating the axes

This process does not require any instruments. It consists of superimposing the measurement of each axis on a strip of paper. As the minor axis rotates over the major and vice versa, the ellipse is drawn at the end common to both (corner of the ticket).
**1.** Marking the axes on the strip of paper.
**2.** Rotating the strip of paper.

## Drawing an ellipse using the foci (known as the gardener's method)

To draw an ellipse, stretch a piece of string between the foci F and F' and the length of the string will determine the curve.

## Using the **rabatment** technique

It's possible to draw a circle in perspective using the diagonal of the square in which it's inscribed. The reference points on the diagonals give four additional points for the drawing line.

First the square, the circle and the diagonals are drawn in the frontal plane to find the new points. The figure is then projected in perspective using the centre point and the '45' points. It's possible to draw only half the figure, given the symmetrical nature of a circle. The lines to the '45' points also provide information on the tangents to the points found.

## Using **division of a square**

To draw a circle it's possible to fix references using the intersections in a square divided into sixteen. There are eight possible intersections:
• From each half of one side of the square towards a corner.
• From the opposite half towards the nearest quarter.

**SCHEMAS**

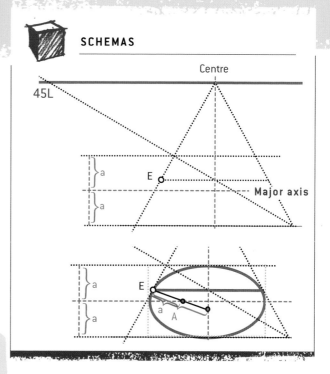

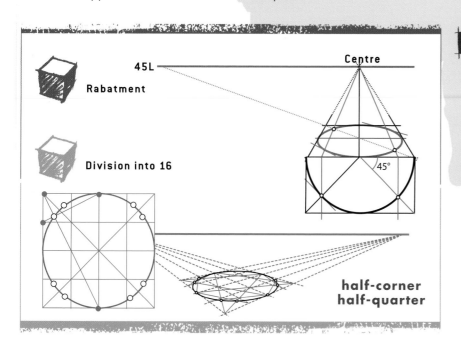

**Rabatment**

**Division into 16**

**half-corner
half-quarter**

## Where the **circle meets the ellipse**

As a circle in perspective is also an ellipse, it can be constructed by applying an elliptical drawing method! By drawing the major axis half way between the top and bottom sides of the square containing the proposed circle, **a** (half the minor axis) is obtained.

Moreover since the '45' point makes it possible to fix the perspective centre of the proposed circle, it is possible to deduce the position of one of its points on the edge: **E**.

By projecting measurement **a** (half the minor axis) between **E** and the major axis and then continuing it to the minor axis, the length of **A** (half the major axis) can be deduced. All that's then required is to draw the (elliptical) circle using the rotating axes technique (see p.108).

109

# SHADOWS

 ## Form **shadow** and **cast** shadow

Where shadow is concerned we distinguish between:
• Form shadow, where the face of an object that is not in light and where there is no external obstacle.
• Cast shadow, which is the area of shadow generated on another surface.

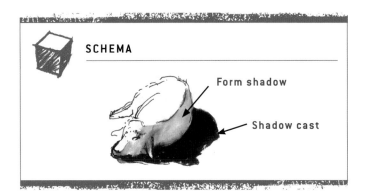

**SCHEMA**

Form shadow

Shadow cast

**All forms can be thought of as figures due to the momentary pause (around an obstacle) of a flow that starts from a point high up and moves on towards an end point.**

*Portrait of Michel*

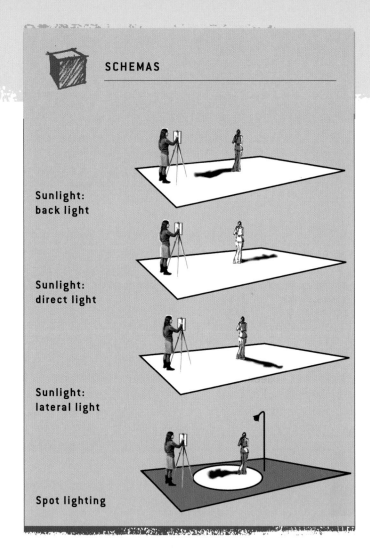

**SCHEMAS**

Sunlight: back light

Sunlight: direct light

Sunlight: lateral light

Spot lighting

● Shadows depend on the position of the light source that creates them. We shall treat them differently depending on whether they come from:
• Light **from the sun** - situated in infinity – three possible types: back light, direct light and lateral light. The sun is a directional light source whose rays are believed to be parallel to each other.
• Light described as **spot lighting**. This is a light source identified by a **point** precisely located in perspective. We also talk of a **one-off** or **occasional** light source.

## Orientation and incidence

In perspective the orientation and incidence of a light source, whatever its nature, must be systematically taken into consideration. The shadow of a point is found where these two lines meet.

The sun is a specific light source in the centre of the solar system. On a human level however, it should be thought of as a directional light source with rays parallel to each other. So for the artist, sunlight has an orientation with a vanishing point on the horizon.

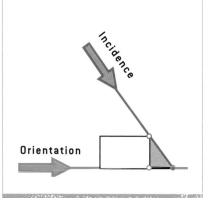

**SCHEMA**

Incidence

Orientation

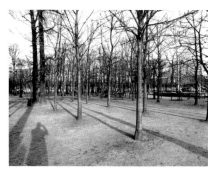

**Direct light**

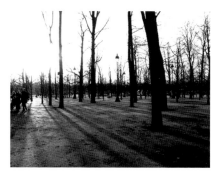

**Back light**

**? Orientation:** direction at the ground line depending on one's position. Orientation is measured according to a point or axis of reference (the gaze, a body, cardinal points). In perspective the notion of orientation underlines the fact that it's a line that stays on the ground and vanishes towards a precise point on the horizon.

**Incidence:** angle formed by a ray of light and the surface it meets. In perspective the surface corresponds to the horizontal plane.

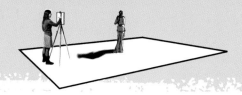

## Shadow back lit by the sun

The light most frequently found in perspective is back light, where shadow is moving towards the artist and the sun is clearly visible above the horizon. Although shadow lengthens as the sun sets, it doesn't get any bigger or smaller in reality. It's only the effect of perspective that gives that illusion. In drawing, shadow gets narrower as it moves away from the artist and wider as it draws nearer.

The **incidence** is given by the sun itself, which is above the horizon, and the **orientation** is perpendicular to the vanishing point of incidence, on the horizon.

The shadow of a point is found where the incidence of light rays and their orientation on the ground intersect. Orientation and incidence are indicated by two vanishing points fixed one above the other (see Inclined Planes, p.64).

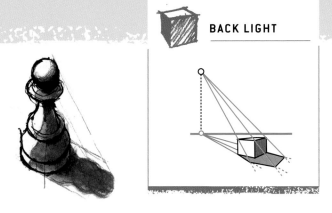

BACK LIGHT

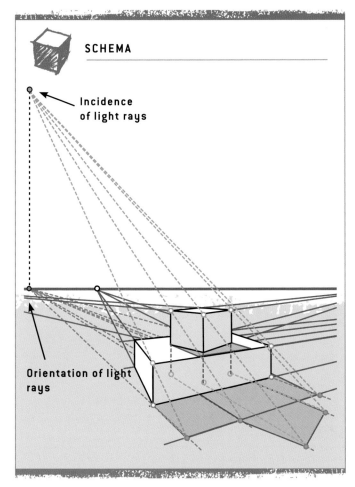

SCHEMA

Incidence of light rays

Orientation of light rays

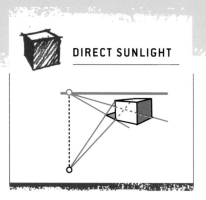

 ## Shadow in **direct sunlight**

Direct lighting is less frequent in perspective. Since the shadows it creates are situated beyond the objects drawn, they are short and scarcely visible. Moreover the artist, with his back to the sun overhead, must imagine the light sloping down in relation to his line of sight, which is less natural for light.

**Incidence:** as the sun is both above and behind the artist, its rays (which are parallel to each other) slope downwards. Their vanishing point is therefore below the horizon.

**Orientation** is on the horizon line, perpendicular to the vanishing point of incidence. The higher the sun in relation to the horizon, the closer the incidence of the rays to the vertical and the lower the vanishing point of incidence will be, quickly going outside the drawing area.

**Direction
of shadow on the step**

**Shadows on a horizontal plane
and on an inclined plane
(steps). The incidence is
the same but the orientation
(ground) changes direction
(slope of the steps).**

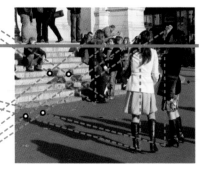

**Orientation
of shadow
on the ground**

**Incidence**

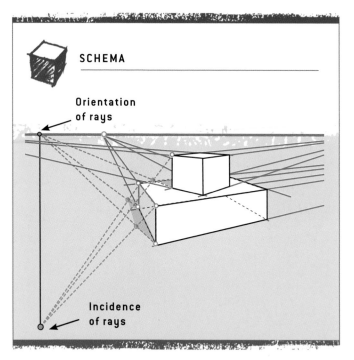

**SCHEMA**

**Orientation
of rays**

**Incidence
of rays**

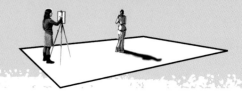

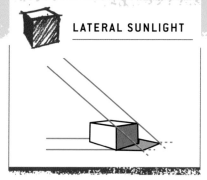

## Shadow in lateral light from the sun

This is the easiest situation to represent because projection of the shadow is in the frontal plane, with no vanishing point. Shadows can therefore be drawn systematically using a T-square and a set square. As space is filled with light from the left or the right, one half of the object drawn is in light while the other is in shadow. As a result, the border between shadow and light is roughly in the middle of the objects drawn, giving the artist important additional spatial information. For the person looking at the picture the edge of the form shadow will naturally indicate the nearest point to the artist in the sagittal plane. Moreover, the slightest change in orientation in relation to the frontal plane will be easy to see and will move some of the volume into the shadow or the light.

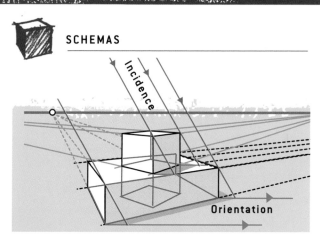

SCHEMAS

The incidence (red lines) always follows the same angle since the sun is at infinity in the frontal plane. The orientation (blue lines) is always horizontal in the picture.

Instruments (T-square, set square) are very useful for drawing lateral shadows.

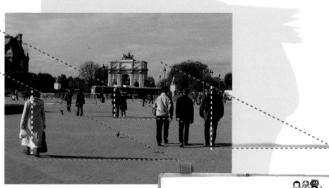

## Spot light **shadow**

Spot light shadow describes a shadow that comes from one specific light source (see p.110).

The source of the **incidence** is the point of light, which is spatially located in perspective ($S^0$).

The **orientation** is perpendicular to the light source on the plane where the shadow falls. For shadows cast on the ground, the point where the incidence and the orientation intersect is found at ground level ($S^2$). For those on an intermediate plane (table), it's at the level of the table ($S^1$) and always perpendicular to the light source.

ARTIFICIAL
LIGHT

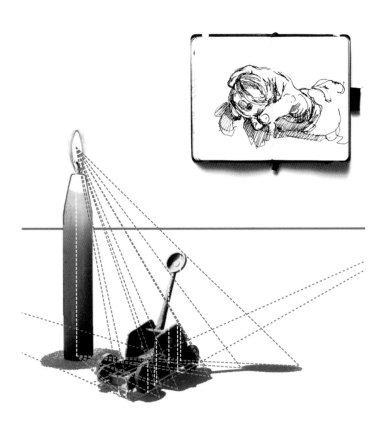

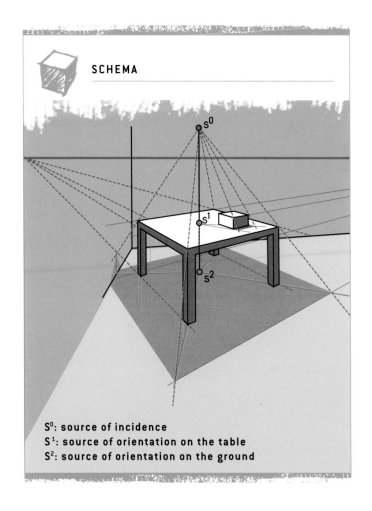

SCHEMA

$S^0$: **source of incidence**
$S^1$: **source of orientation on the table**
$S^2$: **source of orientation on the ground**

# REFLECTIONS

## Horizontal reflective surfaces

To find the reflection of a point on a horizontal surface a vertical line must be drawn from that point to the reflective surface and then projected beyond the surface using a graduated rule, compasses or a scale of height.

For the artist, a reflection on a horizontal plane is a view from below of a symmetrical world flattened against the reflective surface.

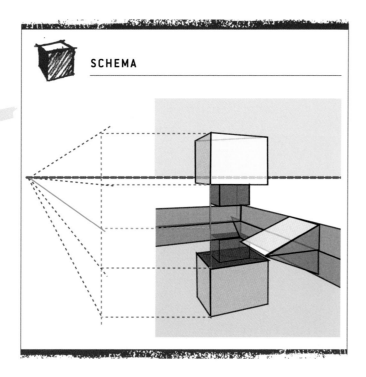

SCHEMA

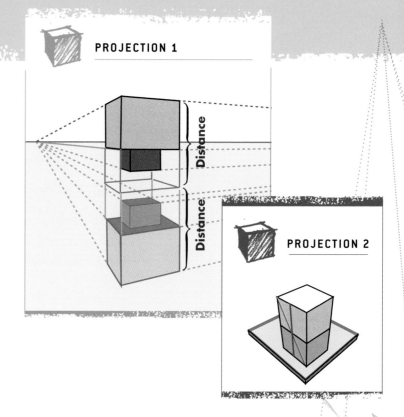

PROJECTION 1

PROJECTION 2

● Locating the reflection
To locate a reflection it's often easier to think of the plane of reflection like a surface that covers the whole picture and then in the end to keep only the part on the reflective surface.

● Projecting distances in a three-dimensional perspective
In a downward perspective the reflection of a point cannot be obtained using compasses or a graduated rule. The artist has to use geometric division (see pp.66-67) taking into account the vanishing point of the verticals.

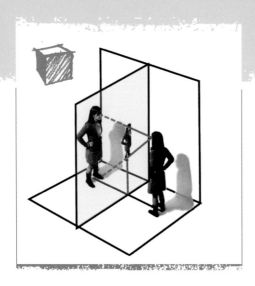

## The artist and his reflection

A mirror is always half way between an artist and his reflection and his image in the mirror will consistently appear to be half the size of the artist himself.

**My face is 18 cm (7 in) from ear to ear. If I put a mirror on the table in the place where I would put a book, my image will be 9 cm (3 ½ in) wide in the mirror.**

**Whatever the distance of the artist from a mirror with specific dimensions (here 4 cm x 12 cm / 1 ½ in x 4 ½ in), he will always see the same portion of his face.**

● The alternation of refraction and reflection changes in calm, rough or choppy water, but the principle of the verticality of the reflections stays the same.

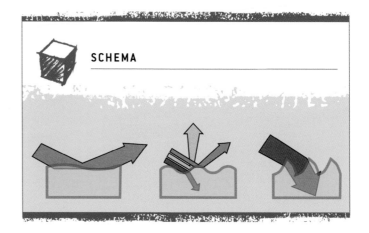

SCHEMA

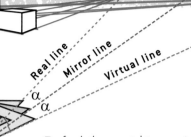

# Axis of reflection and symmetry of construction lines

Reflective surfaces are governed by two basic notions: the axis of reflection and the symmetry of the construction lines.

● **The axis of reflection.** Images are reflected in a mirror perpendicularly to its surface: this is called 'the axis of reflection'. Based on this, reflections can be located if the construction line of the axis of reflection is known. This line will be determined in relation to that of the mirror's surface, since the two form a right angle. It is therefore possible to deduce one according to the other (see Reconstructing a right angle, p.60).

● **Symmetry of construction lines.** A reflective surface reflects not only objects but also the construction lines. For any real known line it is possible to draw a virtual line. It will therefore be easier to construct a reflection if the virtual vanishing points are used as well as projections of distance in the axis of reflection.

To find the vanishing point of a virtual line (V') on the horizon line, the vanishing point of the original line (V) must first be found and then the angle deviation (A) must be projected in relation to the mirror from the point of observation (E).

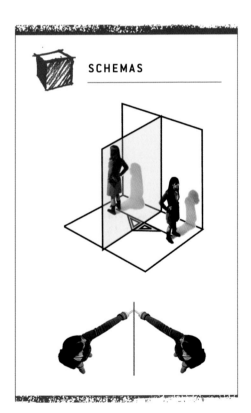

**SCHEMAS**

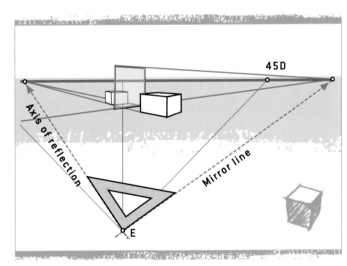

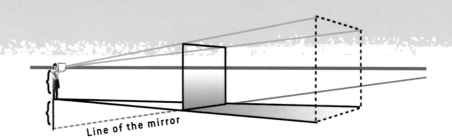

Line of the mirror

# Reciprocal viewpoints

Knowing what is the part of the real world that's visible in a mirror can remove the need for systematic searching for the reflection points of all the objects in the scene and at the same time show what the artist sees on the reflective surface. For this, think of a mirror like a window opening onto a reciprocal world, a world in which there is a virtual artist looking at the real world. It is possible to know from the artist's image what portion of the real space is visible in the mirror: this is the prism of visibility.

**? The artist's image**
This is the reflection of the artist that's visible if he looks perpendicularly to the reflective surface he's representing. His eyes then merge with the vanishing point of the axis of reflection and he's half his actual size in the surface of the mirror (see p.117).

**? The prism of visibility**
This is the space visible in a mirror. To find the prism of visibility the artist must find his own reflection and follow the line from there towards the mirror.

**? Locating the reflection**
Projecting the distance between an object and its reflection is done by frontal measurement, geometrical division or by using the vanishing point of the diagonals (see p.67).

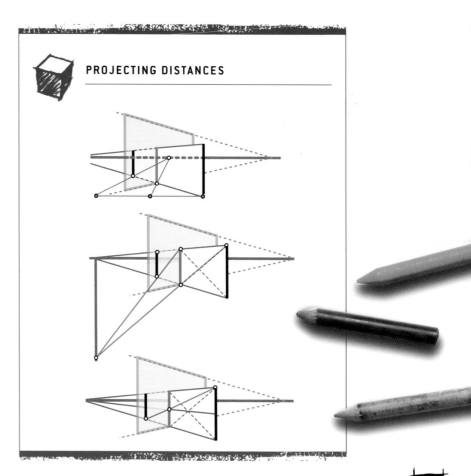

PROJECTING DISTANCES

# AN EXAMPLE IN THREE-DIMENSIONAL PERSPECTIVE

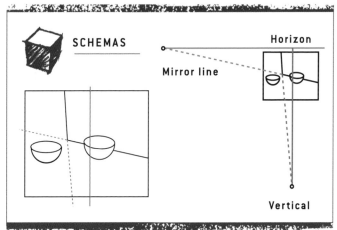

 **Viewpoint**

The viewpoint is defined by fixing the horizon and the vanishing point of the verticals. The mirror line is given by making its base vanish to the horizon and directing the height towards the vanishing point of the verticals. The half-spheres are inscribed in circles and the rims of the bowls take the shape of an ellipse.

 **Light**

The light is direct. The vanishing point of orientation is on the horizon and that of incidence is perpendicular to the orientation, so between the vanishing point of orientation and that of the verticals. The edge of the shadows is the point where the incidence and the orientation intersect.

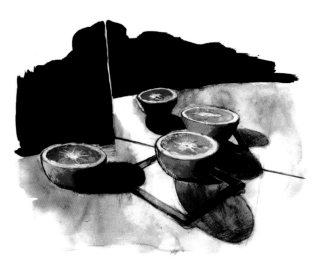

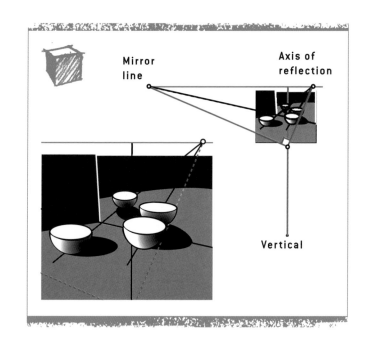

# Reflections

Reflections are located in the axis of reflection at right angles to the mirror line.

## Secondary light source

The mirror creates a new source of back light. This secondary light source is symmetrical to the direct light source and causes new shadows, toning down the previous ones.

## Reflection of the secondary source

The new light source is also reflected in the mirror. The shadows it creates can be located using the axis of reflection and the virtual light source.

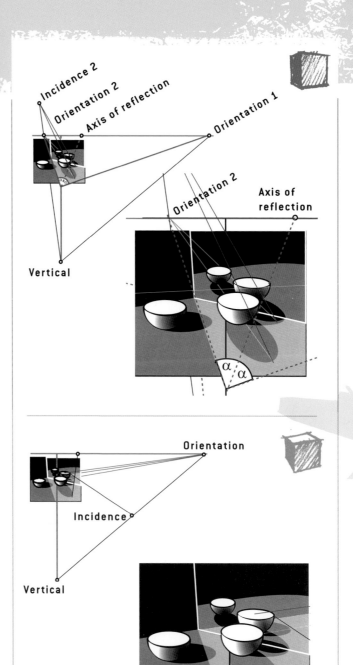

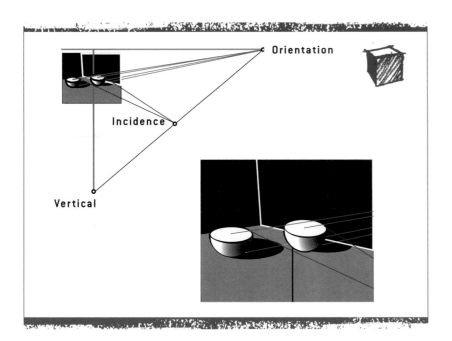

# Principles
# to remember

An ellipsis is the image of a circle in perspective. It is evidence of a good relationship between width and depth. Shadows cause volume to emerge and give an indication of the light. And finally, reflections must correspond to an accurate continuation of space in the presence of a reflective surface.

*A strawberry and some grapes*

##  Ellipses

A circle in perspective is an ellipse.

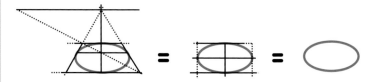

##  Shadows

The shadow of a point is found where the incidence and the orientation of the light intersect.

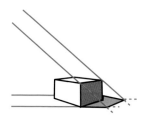

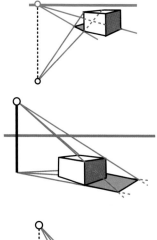

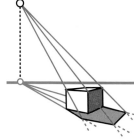

##  Reflections

Reflections are governed by two notions: the axis of reflection and the symmetry of the construction lines.

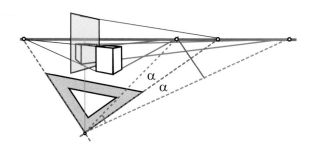

When the muscles of an artist's eye move backwards and forwards between the scene he is observing and the picture plane, he sets different cerebral activities in motion to capture the space, establishing constant connections between the two. These *stimuli* also contribute to his perception of the space, and knowledge of them is an essential aid to understanding and reconstructing it.

# The notion
## of distancing

- Sensory indices
- Positions chosen by the artist
- Geometrical logic
- Breaking down analysis

# SENSORY INDICES

Besides an inevitable shrinking of what we see as we move away there are a number of sensory indices that indicate the proximity or distance of things. They are associated with the ability of a picture to remind us of the feelings of proximity and distance we experience in our everyday lives, which reinforce its spatial aspect.

A strong preoccupation with space and depth of field can be felt in the examples of pictures chosen here, although a traditional perspective process has not necessarily been used. It involves texture of surfaces, clarity and haziness, scenography, transparency of the air, the illusion of movement and stereoscopic vision.

## Texture of surfaces

A subject looks different depending on whether it is close or distant, and a small version of an object does not represent the distant form sufficiently well, because there is a minimum angle below which the eye cannot distinguish between two elements: this is referred to as the eye's resolving power. For example, two elements 10 cm (4 in) apart will not be distinguishable from each other once they are more than 350 m (380 yds) away. In this picture Corot has painted trees at quite varied distances from each other. Three levels of perception can be seen in the foliage overall. In the foreground the leaves are independent elements that look as if they are scattered on the surface of the painting, leaving the scene clearly visible (1).

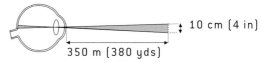

## SCHEMAS

350 m (380 yds)

The resolving power of the eye is the minimum angle required to be able to distinguish between two points.

Jean-Baptiste Corot, *Pond with a fallen tree*

In a middle plane the same leaves are treated like areas of transparency that soften and modify the appearance of the background (2). Lastly, the leaves in the distance become dense shapes, forming a compact unit together (3). So progression is no longer linked to a decrease in size. It's a variation in texture and density. This is the case with all modular elements (textiles, decors etc.).

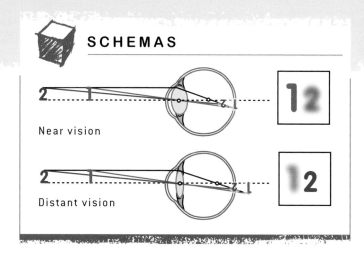

Near vision

Distant vision

near
stretcher
distant

## Clarity and haziness

Focus is a purely physical, mechanical phenomenon that quickly fades and disappears entirely beyond a distance of about 20 metres (20 yards). The muscles around the crystalline lens act on its curve, modifying the distance at which an image is projected on the retina. Characteristic of photography, and also sometimes used in drawing or painting, focus is clear on a standard plane and more hazy on other planes. So there are degrees of clarity in relation to the reference point on which the attention is fixed, depending on how close or far away the rest of the scene is. In this example the observer's attention is drawn to the dog's eyes.

Gerhard Richter, *Jockel*, 1967

## Scenography

An interplay of the frame and the plane/volume or in-field/out-of-field ambiguity is used to highlight the effect of depth by minimising the indices that allow the observer to think of the picture as a flat space. The eye searches for markers and the mind is drawn into deceptive spatial deductions. The effectiveness of imitation is what the artist is trying to achieve.

The idea behind the trompe l'oeil picture here is to make the viewer believe in the existence of a stretcher (grey in the schema), which is supposedly part of the picture surface. The composition is arranged in relation to this reference point, playing on the elements at the front and the back.

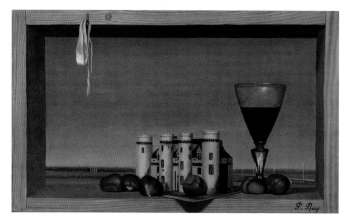

Pierre Roy, *The Saint-Michel Summer*, 1932

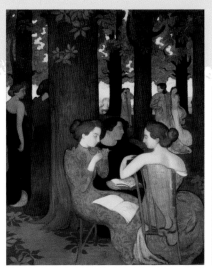

Maurice Denis, *The Muses*, 1893

## Overlapping

It is possible to create different levels of depth by giving greater importance to the elements in the foreground and less to those in the background. This approach involves successive overlapping of the elements, an interplay between in front and behind.

In this painting by Maurice Denis each plane covers part of the one behind it, and the importance of the elements depicted can be determined from the way the overlapping is done, from the nearest to the most distant.

## The illusion of movement

If two elements at different distances move at the same speed, the nearest one will tend to cross our field of vision more quickly. As a result, distant movements are relatively steady compared to near movements, which are more fleeting. In a picture, near movement is more transparent and reworked than distant movement which has a greater degree of stability and inertia. So there is a hierarchy of graphic resolution depending on the proximity of a movement in a scene.

Today, considerations regarding the visualisation of movement are a key area of research on the perception of space, because they raise important commercial issues with respect to animation and video games.

In this painting by Raoul Dufy there is a noticeable progression in the treatment of the moving figures. Those nearest are translucent and imprecise (1). They gain more shape (2) and sharpness (3) as they grow more distant finishing with the perfectly delineated motionless lighthouse (4) at the end of the jetty.

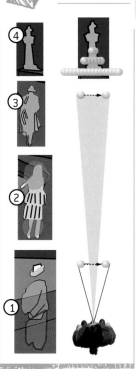

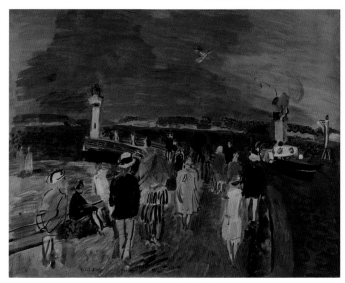

Raoul Dufy, *Honfleur Jetty*, 1928

## Stereoscopic vision

Because our eyes are about 7 cm (3½ in) apart the viewpoint of each is different. Analysis of this difference helps our brain to perceive depth that is relatively near. In the same way that stereophonic sound reconstructs a body of sound perceived by each ear differently, a stereoscopic image reconstructs a visual space according to the perception of each eye. An artist often closes one eye to choose between two visual solutions, for sight belongs neither just to the right eye nor the left, but is a binocular outcome that takes both views into account to deliver what is, in the end, a virtual viewpoint. Vision is a compromise between several possibilities that combine to find an intelligible solution.

The same is true for the graphic, photographic and pictorial reconstruction of a space: it's a unique compromise that takes account of our multiple perception. To reconstruct depth as fully as possible the specific viewpoint of each eye must be reconstructed at the same time.

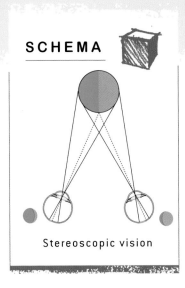

SCHEMA — SCHEMA

Stereoscopic vision

Transparency of the air

Henri Lambert, *Return of the pirogue*, 1904
Below: Charles Mendel stereoscope

Here we see a photograph taken with a camera that has two lenses 7 cm (3½ in) apart, which takes two photographs at the same time. When the photographs are developed they are viewed with a stereoscope which recreates the binocular sensation.

## Transparency of the air

The sky is naturally charged with particles in suspension, the density of which can obscure the landscape, toning down colours in the distance. As a result, colours, values and saturations merge and the sky, which is blue all over because of extensive diffraction of short wavelengths, dominates the scene. Elements in the distance lose their sharpness and their colour range becomes progressively limited.

This phenomenon has been known to painters since the Renaissance period and is rendered in painting by the 'sfumato' technique. It is more evident when landscapes are heavy with humidity or dust.

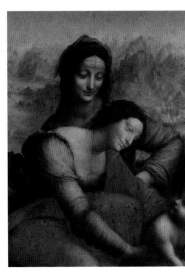

Léonard de Vinci,
*The Virgin and Child
with Saint Anne* (detail)

# POSITIONS CHOSEN BY THE ARTIST

Here we shall describe four very different positions the artist can choose for observing and reconstructing space. The same scene – some bits and pieces on a shelf – is represented in all four examples viewed in different conditions.

 ## A reflective view

The first stage of perception for an artist is a reflective view based on the visual signs he sees in front of him. His drawing moves between substance and form and a good many hiccups can occur caused by intensities of light or the strength of the lines in the space. He tries not to separate the objects from their place, and systematically copies and recopies a jumble of lines and shapes, some dark and some light. He has to try and think of the space as a flat image where the notion of volume no longer has any sense.

A reflective view: the space is recreated with no consideration for volume.

 ## An 'egocentric' view

The artist feels what he sees. His sharp inquiring gaze scrutinizes space from a particular viewpoint. He is fully conscious of the weight of objects, the texture of the surfaces and the prominence of the edges. He understands the lines and knows what they represent, what they define. What he sees is based on his physical experience of space. He alone can feel the distance and the proximity in the space and the things that fill it. His perception of the scene is 'egocentric' because it relates to personal conditions of observation and 'kinaesthetic' because it reminds him of physical sensations he has already experienced.

An egocentric view: the space is considered from the artist's position and his awareness of life up to that point.

 **Paradigm:** a widely accepted model.

**Kinaesthetic:** relating to the sensations of the body and its movements in space.

## An 'allocentric' view

Everything the artist sees is constructible and develops from a plane that is defined according to an x and a y co-ordinate. The centres of gravity have identifiable perpendiculars and so the artist tries to understand the distances between things, to notice the symmetries and identify the volume envelopes while being fully aware of the horizontal and vertical nature of the world he is drawing. Everything has a left side, a right side, a front, a back, a top and a bottom. The artist is therefore able to establish a layout of what he's looking at. It doesn't matter where he's positioned; he understands the space he is drawing geometrically and tries to convey that understanding. True, his pencil is gliding over a flat surface, but he has the feeling that it's moving in a three-dimensional space, of which he is not necessarily a part. His perception of the world is 'allocentric'; he sees the space in relation to a system of external references.

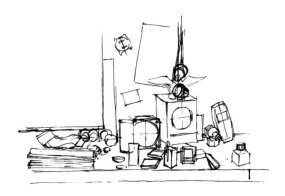

An 'allocentric' view: the space is set up according to rules common to all potential observers.

## A paradigmatic view

Rather than focus on events in the external world, the artist's eye turns to his memory, towards the personal image-maker he's developed for himself since birth. His mind is full of pictures and he searches out from among them those that correspond to what he sees. The selection process is very thorough and soon he's trying to understand things he's not yet familiar with. He uses the formal vocabulary he's developed to communicate his view of events and things. His actions are guided by the emotions that wash over him.

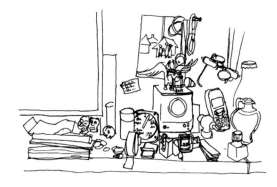

A paradigmatic view: the space is 'scanned', a bit like leafing through a catalogue.

> **?** **Allocentric (or exocentric):** describes a space or object whose position is shown in relation to coordinates external to the observer.
>
> **Egocentric:** describes a space or object whose position is shown in relation to the observer.

# GEOMETRICAL LOGIC

Being aware of one's environment is one thing, but reconstructing it on a flat surface is another. Some details of space which can appear difficult to understand are not easy to place on a sheet of paper. So the artist naturally resorts to logical and deductive processes to help him.

The three processes we are using to help us in this book are:
– geometric optics,
– synthetic geometry,
– projective geometry.

A comprehensive understanding of the processes used allows the artist to switch more easily from one form of logic to another to resolve the space he is representing.

## Ibn al Haytham's logic: optical geometrics

The elements that are seen and reproduced are given according to an angular deviation, an azimuth or an elevation. Everything is positioned in relation to the viewpoint. We are the centre of the space surrounding us. This is the practical view of the soldier, the astronomer and the sailor: 'Enemy at 10 o'clock', 'Star two digits from the North Star', 'Headland 20° starboard'. The artist trusts only his line of sight and the place occupied by the objects in his field of vision.

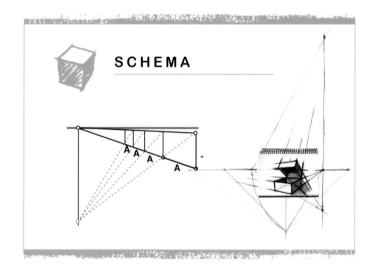

SCHEMA

**? Ibn al Haytham** (also known by the name Alhazen): physicist and mathematician from Arabia (Iraq) who lived around the year one thousand, author of discourses on optics, early theories of geometric optics and a descriptive analysis of sight.

# Euclide logic:
## synthetic geometry

The artist is guided in this intellectual work by pure geometry, like a surveyor. Based on a deductive approach, it uses techniques of intersection, construction and division. The artist works inside a space that he experiences according to a geometric logic based on the division of volumes and topographic positioning.

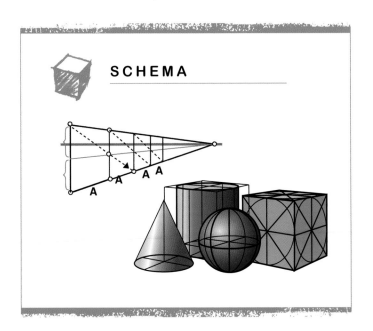

SCHEMA

> **Euclid:** Greek mathematician from the 3rd century BC, author of *Elements*, a work in 13 volumes that forms the basis of plane geometry and solid geometry.

# Desargues' logic:
## projective geometry

The frontal plane (the drawing or painting) acts as an interface between the space seen and the space experienced. There is a two-way movement between the space and the projection surface on which the artist fixes points using the rabatment technique. Projective geometry is a more complex deductive logic because it brings sequential graphic actions into play. OpenGL (Open Graphics Library) for calculating 3D views on a computer is a computer language based on projective geometry.

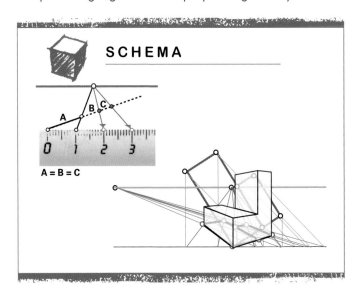

SCHEMA

A = B = C

> **Desargues:** 17th century French mathematician and architect, founder of projective geometry and author of *Proposed draft of an attempt to deal with the events of the meeting of a cone with a plane.*

# BREAKING DOWN
# ANALYSIS

An artist moves from one way of thinking to another depending on the possibilities in front of him. One thought leads to another and he looks around, carried along by the different forms of logic used to understand and reconstruct space. He will draw on one particular form of logic depending on the configuration of the space to be reconstructed, until he meets some resistance. He will then instinctively have to apply another form of logic to overcome this, and will continue in this way, using a policy of the most effective.

Taken one by one, these different forms of logic have the distinctive characteristic of leading the artist towards a systematic construction of space, disregarding the limits of human perception. Each one can solve a spatial situation in a different way. One logic of construction is coherent in itself, but the result is not necessarily in line with our vision. Used together however, they act as a safeguard, each fulfilling a complementary role to the others.

It seems then, that to understand space the brain has to call on several forms of logic that confirm and verify each other; and that by providing a sort of reasoned intellectual stroll through our world in this way, drawing from observation is a creative process. It shows images stripped of the elements that the artist considered superfluous. Drawings from observation are mere skeletons compared with the photographs we're used to, because the artist makes a rigorous selection from all the elements potentially visible.

Paradoxically, this helps us to understand the space represented by offering us a pre-selected and partially solved version. This places drawing in perspective in an ambiguous situation, on the border between the substitution and manipulation of space, between clarification and appropriation.

Aldo Rossi, *Social services building in the port of Naples*, 1968

In this plate Aldo Rossi offers a perfectly coherent project drawing, constantly switching from a viewpoint to an aerial view of an idea, from a general diagram to a detailed perspective, or from a detail to a general view.

# The time-space continuum

The concepts of time and space are linked. A drawing has a beginning and an end from a spatial point of view as well as a temporal one. In space it is limited by its size and its support; in time it is made up of pencil strokes that follow on from each other in line with those already on the paper; no stage can skipped, from the beginning to the end.

Space and time are continuous. A drawing, which for the artist is a substitute for the space observed, has the same characteristics of space-time continuity. That's probably why a discontinued line is associated with the idea of rupture. That, at least, is what perspective teaches us: a continuous, progressive perception. The more distant the objects observed, the smaller their image becomes; the more an artist looks up to observe the space, the higher the elements in the composition will be. There is an inexorable progression in these formulae that brings perspective very close to what we experience in space and time.

*Paris, the Pont-Neuf*

*London, the British Museum*

# Different types of perception

From fluidity of time and space it's only one step to the notion that graphic fluidity is necessary to draw space. However, neuroscience and physiology have largely demonstrated that perception of space follows different paths depending on the objectives sought.

• The brain treats objects that are more than arm's length away differently, because they are no longer within the grasp.

• Beyond a distance of three or four metres, objects are not subject to different levels of focus (blurred/sharp) and are not treated in the same way by the brain.

• The eye does not differentiate between objects that are more than about twenty metres away. Another area of activity in the brain takes over in such circumstances.

These stages are all perceived differently by the brain, but treated progressively and continuously by perspective, where the world simply shrinks as objects become more distant. So drawing from observation is not necessarily a fluid and progressive activity and there is no systematic hierarchy between objects that fill a space.

# Decomposition and recomposition

Perception involves many other elements: emotional response, concentration of the visual field, recognition of objects according to their context and in relation to each other. The perception of space is a lot more diverse than perspective would suggest, and as such it's natural for the artist or painter representing space to combine different discontinuous approaches, which a Cartesian mind would describe as "disjointed" behaviour.

The artist allows his emotions to take over. He has to break the space down intuitively, calling on different feelings, and when the time comes to put it back together again he recomposes, superimposes and combines them.

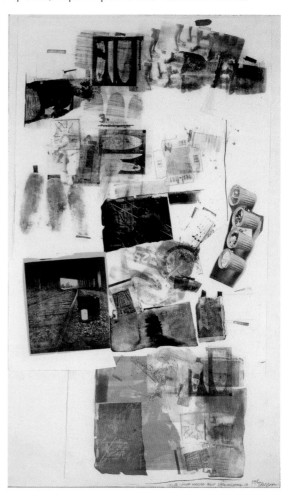

Robert Rauschenberg, *Collage of original proofs*, 1968
[given as 1958 in List of Works reproduced]

## Space is an idea

An understanding of space does not boil down to the projection of an image on the cerebral cortex with left-hand cells on the left- and right-hand cells on the right, as is the case, for example, with the retina. The same is true for a graphic description of space: the juxtaposition of elements according to their layout in space does not necessarily correspond to intellectual reality. An artist can change the spatial order of things according to the priorities of his senses. This is where perspective has its limitations, for the solution it offers cannot escape the principles of continuity and progression.

## A graphic link between space and thought

When an artist creates a drawing in perspective he establishes a bridge between his real-life physical experience of space and his visual recognition of it, at the same time ensuring that his picture will be able to reconstruct that bridge for the eyes of future "spectators". Once achieved, perspective retains that ability to reconstruct the artist's ideas and the space he's represented. It's a graphic interface between space and thought.

## A one-way language

Because it has to be comprehensible, perspective is a sort of language. The assimilation of a certain number of codes is necessary to practise it, but paradoxically no training is needed to decode it! Perspective is a one-way code, the purpose of which is to be perceived intuitively without any special knowledge; it uses specialist knowledge in the service of intuitive interpretation.

## The illusion of reality

These last two aspects, a graphic link and instantaneous language, make perspective a particularly attractive discipline, giving the artist and the observer the illusion of being able to create a tangible viewpoint from start to finish. While intellectual viewpoints can be clearly identified, like opinion bearers, visual viewpoints purport to come straight from reality, and sometimes even to replace it. At least that is what perspective would have us believe, by substituting itself for space using a mechanical process in which the artist is merely the instrument of execution.

Ettore Sottsass, *Supercomputer "Elea"*, 1958

# Principles to remember

An artist has to juggle different deductive approaches and processes in order to fix points in a drawing according to a pre-established arrangement in space. He also has to be conscious of the sensory indices that enable him to gauge distances. And finally, he must be able to depart from convention, depending on the information he is receiving.

*King's Road, Chelsea*

## Sensory indices

There are a certain number of sensory indices that remind us of the feelings of proximity or distance we experience in our daily lives: the texture of surfaces, clarity and haziness, scenography, transparency of air, overlapping, the illusion of movement and stereoscopic vision.

## Geometrical logic

The artist must be conscious of the mental processes going on: optical geometry, synthetic geometry and projective geometry. Cross-checking between these different forms of logic makes it possible to solve a good number of spatial situations.

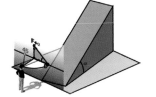

## Positions chosen by the artist

The approaches used to capture space must vary. The view can move from reflective to schematic. Space can be considered from the artist's position or established according to common rules.

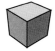
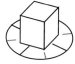

## Breaking down analysis

The reconstruction of space goes beyond perspective. It must take into account different levels of analysis and the dialogue established with the observer.

Different types of perception

Perspective as dialogue

The eyes of a chameleon can turn at 180°. They move independently of each other and have exceptional focusing powers. It's rather as though two observers standing back to back in the dark, were examining their environment with a telemetrical torch and exchanging information verbally.
What would their perception of space be in such a case?
What kind of deductions would they make?
Can we still talk about vision?
Added to this, the chameleon has four 'hands' with several opposable digits, a tongue that darts out at any moment in a precise spot in its immediate space, a prehensile tail and an astonishing ability to mimic form and colour. It's a perfect interpreter of space.

# Index

# Glossary

**Allocentric (or exocentric):** describes a space or object whose position is shown in relation to coordinates external to the observer.

**Angle of vision:** angular aperture through which the scene is observed. It concerns a relationship between the distance and size of the object or space drawn.

**Axonometry:** two-dimensional representation of an object or space whose three dimensions are each projected on a normed axis and therefore do not display any perspective shrinking. There are normally three types of axonometric code:
**isometric** where all the angles are equal, **dimetric** with two different angle relationships and **trimetric** with three different angle relationships.

**Azimuth:** the angle between two lines (one of which acts as reference) on a horizontal plane around the observer.

**Cone of vision:** cone of which the narrow end corresponds to the observer and the wide end to the flat picture surface. The edges of the cone of vision define the artist's visual field.

**Desargues:** 17th century French mathematician and architect, founder of projective geometry and author of *Proposed draft of an attempt to deal with the events of the meeting of a cone with a plane.*

**Distance:** the distance between the artist and the picture plane.

**Egocentric:** describes a space or object whose position is given in relation to the observer.

**Elevation:** a vertical angle that creates a given construction line in relation to the horizontal.

**Ellipse:** a flat curved line for which the sum of the distances from each point in relation to two fixed points (the foci F and F') is constant. An ellipse is different from a circle in that it has two axes of different lengths: the minor axis (red) and the major axis (blue).

**Euclid:** Greek mathematician from the 3rd century BC, author of *Elements*, a work in 13 volumes that forms the basis of plane geometry and solid geometry.

**Frontal plane:** is perpendicular to the line of sight (like the forehead). It separates front from back.

**Geometric division of space:** geometric division is based on a deductive approach to the perspective space already in place. The artist uses his knowledge of geometry to follow principles of geometric logic based on intersection, construction and division.

**Horizon:** a straight line that symbolizes the horizontal plane passing through the artist's line of sight.

**Horizontal plane:** is parallel to the ground. It separates top from bottom.

**Ibn al Haytham:** (also known by the name Alhazen): physicist and mathematician from Arabia (Iraq) who lived around the year one thousand, author of discourses on optics, early theories of geometric optics and a descriptive analysis of sight.

**Incidence:** angle formed by a ray of light and the surface it meets. In perspective the surface of reference corresponds to the horizontal plane.

**Kinaesthetic:** relating to the sensations of the body and its movements in space.

**Locating the reflection:** projecting the distance between an object and its reflection is done by frontal measurement, geometrical division or by using the vanishing point of the diagonals (see p.67).

**Orientation:** direction at the ground line depending on one's position. Orientation is measured according to a point or axis of reference (the gaze, a body, cardinal points, etc.). In perspective the notion of orientation underlines the fact that it's a line that stays on the ground and vanishes towards a precise point on the horizon.

**Orthonormalized:** established on an orthogonal basis, where each axis uses an identical norm.

**Paradigm:** a widely accepted model.

**Prism of visibility:** this is the space visible in a mirror. To find the prism of visibility the artist must find his own reflection and follow the line from there towards the mirror.

**Rabatment:** a process that consists of rotating a measurement taken in the depth of the visual field on the picture plane.

**Sagittal plane:** is the symmetry plane of the body. It separates left from right.

**Scale of heights:** vertical measurement area on which heights are projected in relation to their distance. Imagine a wall that runs across the scene.

**The artist's image:** this is the reflection of the artist that's visible if he looks perpendicularly to the reflective surface he's representing. His eyes then merge with the vanishing point of the axis of reflection and he's half his actual size in the surface of the mirror.

**Triangle of equilibrium:** triangle established between the three vanishing points, each of which defines one of the three dimensions of the space drawn.

**Vanishing point:** point towards which all straight lines leading in a given direction seem to move. For the artist it's a point of convergence but for the person looking at the picture it's a direction.

Above the Mediterranean